VICTORIA AND ALBERT MUSEUM

Catalogue of Foreign Paintings

II. 1800-1900

C. M. KAUFFMANN

London 1973

© *Crown copyright 1973*

SBN 901486 48 5

90p net

Printed for Her Majesty's Stationery Office by Eyre & Spottiswoode Ltd,
Thanet Press, Margate
Dd. 133811. 469. K26

Contents

Foreword

THIS CATALOGUE is divided into two volumes: the first covers paintings produced before 1800, the present volume deals with those painted after that date. It includes foreign paintings in oil and tempera but not watercolours. Objects not in the Department of Paintings have been included where they contain painted surfaces of major importance. Most of these are in the Department of Furniture and Woodwork and are marked (F. & W.) accordingly. Paintings on glass have not been included: these are to be found principally in the Department of Ceramics. The Introduction outlining the history of the collection, applies to both volumes.

The paintings catalogued are, as a rule, available at the Museum, except for those of the Bethnal Green Museum. They are on view in the Foreign Paintings Gallery (Room 87) the Ionides and Jones Galleries (Rooms 105 and 5–7 respectively) and in the Primary Collections. Those not exhibited are usually available upon application in the Print Room. The paintings in the Wellington Museum at Apsley House and those at Ham House are not included in this catalogue.

Debts of gratitude for help received are so numerous that they cannot be listed in full. Specific instances are recorded in their place, but it should here be said that considerable help was received from Sir Anthony Blunt, Mr W. Katz, Mr Arthur Kauffmann, Professor Otto Kurz, Miss Mirella Levi d'Ancona, Mr Neil MacLaren, Mr Denis Mahon, Mr Philip Pouncey and Mr Malcolm Waddingham. The authorities of the Rijksbureau voor Kunsthistorische Documentatie have been unfailingly helpful, as have the staffs of the Witt Library of the Courtauld Institute and the Photographic Collection of the Warburg Institute, where part of the work was carried out.

A debt must be recorded to numerous colleagues in the Museum, not least those in the Conservation Department, for aid and advice on many points. Mention should also be made of Basil Long, a former Keeper of the Department, whose catalogues and meticulous documentation formed the basis of the present work. The typing of this catalogue was done by Miss Camilla Robinson and Miss Anita Heywood, whose accuracy was remarkable. The whole of the text was checked and many errors corrected by Mrs Lucy Gent, temporary Research Assistant in the Department, who also contributed several of the Italian school entries.

C. M. KAUFFMANN

Assistant Keeper, Department of Paintings

Introduction

THE MUSEUM'S collection of oil paintings dates back to the Sheepshanks gift of 1857, which was to be the foundation stone of the Gallery of British Art. The collection of foreign paintings has a more modest history and owes its beginnings to the acquisition of a variety of pictures 'bought as an illustration of costume'. However, among the early purchases – many of which we owe to J. C. Robinson, the percipient Art Referee – are the Cologne Master of St Ursula, *Martyrdom of St Ursula*, the Apocalypse altar-piece by a follower of Master Bertram of Hamburg and the great Valencian altar-piece of St George, bought in 1857, 1859 and 1864 respectively. At the same period the collection of Jules Soulages of Toulouse, which had been exhibited at the Manchester Art Treasures exhibition of 1857, was bought in stages by a body of subscribers.[1] This included the well-known *St Dominic* by Giovanni Bellini, which has, together with six other of the Museum's paintings, been on permanent loan at the National Gallery since 1895.

The bulk of the collection, however, has come from bequests rather than purchases. The three most important – those of the Rev. C. H. Townshend (1868), John Jones (1882) and C. A. Ionides (1900) – will be described in more detail, but special mention should also be made of three others. Those of the Rev. Alexander Dyce (1869) and of John Forster (1876) are best known for their books, manuscripts, prints and drawings; the paintings in them are mainly British, but included some foreign artists,[2] while that of John Parsons (1870) added a considerable number of works by seventeenth century Dutch artists.

The Rev. Chauncy Hare Townshend, who died in 1868, was an omnivorous collector. He left to the Museum a large collection of pictures, water-colours, prints and drawings, gem stones, cameos and intaglios, not to mention 4,218 Swiss coins, subsequently deposited on long loan in the British Museum. A further bequest of glass, watches, curios and geological specimens was made to the Museum at Wisbech, his home town. Townshend, author of *Facts of mesmerism*, 1840, was a friend of Dickens, whom he met in 1840 and who visited him at his house in Lausanne on several occasions. Indeed, he made Dickens his literary executor and the latter faithfully edited and published Townshend's

[1] J. C. Robinson, *Catalogue of the Soulages Collection*, 1856.
[2] *Dyce Collection. A catalogue of the paintings, miniatures, drawings, etc.,* 1874.
Forster Collection. A catalogue of the paintings, manuscripts, etc., 1893.

Religious opinions, 1869, even though he preferred to describe them as 'Religious Hiccoughs'.[3] Townshend's collection enjoys the distinction of having been thought sufficiently important to be described in Dr Waagen's *Treasures of art in Great Britain* (*Supp.*, 1857, p. 176 f.).

Of the 186 oil paintings in his bequest, 141 are Continental, and of these some 40 are Old Masters and about 100 are by the collector's contemporaries. The former group consists mainly of seventeenth century Dutch paintings, not very different in type from those in Parsons' collection and in many others formed at this time. As Waagen noted on seeing only a small part of his collection, its chief interest lay in that it was 'interspersed with admirable works by the best painters of Belgium, Holland, Germany and Switzerland, which are comparatively seldom met with in England.' Dating mainly from the 1840s and '50s, these form an instructive comparison with Sheepshanks' gift of early Victorian English paintings, and serve to demonstrate the international character of the style and subject matter of the period. Townshend's collection was rich in German painting, particularly of the Munich school (Morgenstern, Rottmann, Schleich), but, as he spent his winters in Lausanne, it is the Swiss school that predominates. The artists of Geneva and Lausanne with their genre scenes and Alpine views – including Menn, Bocion, Calame and Hornung – are better represented than anywhere outside Switzerland. Indeed, when it became known that Townshend had left these pictures to the South Kensington Museum, the city council of Lausanne did its utmost to prevent their departure and it was only through the personal intervention of the British Ambassador in Bern that their release was secured.

The collection of John Jones, bequeathed in 1882, was of a totally different character. Jones was a regimental tailor who furnished his house in Piccadilly in a consistent eighteenth century style. The bequest has been retained as a single unit and the Jones galleries in the Museum provide an impressive display of French eighteenth century furniture, ceramics and objects of *vertu* as well as paintings.[4] Some of the Museum's finest works are to be found in the foreign paintings in the bequest, over fifty in number, including a group of French eighteenth century paintings by De Troy, Lancret, Pater and Boucher which has – apart from the Wallace Collection – no equal in England.

If the Jones Collection is justly famous for its emphasis on French rococo, the bequest of Constantine Alexander Ionides, which entered the Museum in 1900, is an outstanding example of a collection ranging over a wide variety of styles in which almost every item was selected – as time has shown – with an unerring eye for quality.

The merchant firm of Ionides, the first Greek house established in

[3]*Charles Dickens*, exhibition, V. & A. Museum 1970, p. 116, P. 22–3; E. Johnson, *Charles Dickens, his tragedy and triumph*, 1953, pp. 300, 785; and there are various references to Townshend in *The letters of Charles Dickens*, ed. G. Hogarth & M. Dickens, 1893, pp. 476, 482, 497, etc.; *The letters of Charles Dickens* (Pilgrim Ed.), ed. M. House & G. Storey, ii, 1969, pp. 110, 112.

[4]B. S. Long, *Catalogue of the Jones Collection*, pt iii, *Paintings and miniatures*, 1923; an issue of *Apollo* (March 1972) has been devoted to the Jones Collection.

London, dates back to 1815.[5] Alexander, son of Constantine Ionides, the firm's founder, came to England in 1827 and became a British subject ten years later. His eldest son, Constantine Alexander, the Museum's bene-factor, was born in 1833 at Cheetham Hill, Manchester, and spent his youth representing his father's firm in Greece and Turkey. On one of his trips he met Agathonike Fenerli, the daughter of a business colleague, and married her in 1860. They settled in England in 1864, living for more than thirty years at 8 Holland Villas Road, London. His son recounts that the early years in London, when Constantine Alexander worked for a firm of stockbrokers before setting up on his own on the Stock Exchange, were fairly lean, and it appears that the bulk of the collection of paintings was acquired in the decade 1875–85. Ionides was a patron of contemporary artists working in England, and Legros and Watts in particular were friends of the family, but it is for the foreign paintings that the collection is best known. They fall into two groups. The old masters centred on the seventeenth century, with the Louis Le Nain and the early Rembrandt outstanding. The French nineteenth century – a focus of interest in part due to the influence of Legros – is represented by Ingres, Delacroix, Courbet, the Barbizon school, Fantin-Latour and an early Degas. Although Ionides never became, like Henry Hill of Brighton, an avant-garde collector of the Impressionists, he was without doubt in the van of taste in the 1870s and '80s.[6]

The terms of the bequest stipulated that the collection was to be shown as a separate entity, as was already the case with the Jones Collection. This condition may be criticized on the grounds that it renders impossible any attempt to exhibit the Museums collection of paintings by schools or periods. And yet it is possible that this disadvantage is outweighed by the fact that the visitor is able to see a collection more or less as it was when it was formed nearly a century ago. The taste of an enlightened collector can be more fully appreciated and the collection more readily studied as a visible document in the history of taste and collecting than is possible in a picture gallery set out on orthodox lines.

Although occasional gifts and bequests were still received after 1900, the Museum virtually ceased to acquire foreign paintings after that date.

The discussion of the donors has given some indication of the collection's strength: the Dutch seventeenth century, the French eighteenth and nineteenth centuries and the Swiss and German nineteenth century, but it should be added that the Italian School is also well represented. There are two large painted crucifixes of which one – Umbrian school late twelfth century – is the earliest example of its kind to be seen in England. Italian painting of the fourteenth-sixteenth centuries is represented by, among others, Nardo di Cione, Barnaba da Modena, Botticelli, Carlo

[5]A. C. Ionides junior, *Ion: a grandfather's tale*, Dublin, 1927, p. 2. See also *Notes and index* to the above, privately printed, 1927.

[6]D. Cooper, *The Courtauld Collection*, 1954, p. 60; R. Pickvance, 'Henry Hill: an untypical Victorian collector' in *Apollo*, lxxvi, 1962, p. 789. Two of Ionides' Millets were bought at the Hill sale in 1889.

Crivelli, Bernardino Fungai and Domenico Beccafumi. There are detached frescoes by Pier Francesco Fiorentino, Floriano Ferramola, a follower of Luini, Perino del Vaga and Lodovico Carracci, while painting as applied to the decorative arts appears on several fine Florentine and Sienese *cassoni* forming part of the Furniture and Woodwork Department.

Mention should also be made of the group of paintings in unusual media: oil on stone (Rottenhammer, etc.), encaustic on slate (Cornacchini), grisailles in imitation of engravings (Salm) and of relief (Sauvage). Indeed, the wide variety of schools, periods and media represented renders this an ideal teaching collection for visitors and students alike and its master-pieces need no further introduction.

Abbreviations

Bartsch	A. Bartsch, *Le peintre graveur*, Vienna, 1803–21.
B. F. A .C	Burlington Fine Arts Club.
Burl. Mag.	*Burlington Magazine.*
1893 *Catalogue*	*A catalogue of the National Gallery of British Art at South Kensington with a supplement containing works by modern foreign artists and Old Masters, 1893.*
F. & W.	Furniture and Woodwork Department.
Hofstede de Groot	C. Hofstede de Groot, *A catalogue raisonné of the works of the most eminent Dutch Painters of the seventeenth century, 1907–27.*
J. W. C. I.	*Journal of the Warburg and Courtauld Institutes.*
K. d. K.	Klassiker der Kunst.
Long, *Cat. Ionides Coll.*, 1925	B. S. Long, *Catalogue of the Constantine Alexander Ionides Collection, i, Paintings 1925.*
Long, *Cat. Jones Coll.*, 1923	B. S. Long, *Catalogue of the Jones Collection, pt iii, Paintings and miniatures, 1923.*
Monkhouse, 1884	C. Monkhouse, 'The Constantine Ionides Collection' in *Magazine of Art*, vii, 1884, pp. 36–44, 208–14.
N. G.	National Gallery.
R. A.	Royal Academy.

Shaw Sparrow, 1892

W. Shaw Sparrow, 'The Dixon
Bequest at Bethnal Green' in
Magazine of Art, xv, 1892.

Smith, *Cat. Rais.*

J. Smith, *A catalogue raisonné of the
works of the most eminent Dutch,
Flemish and French painters*, 1892–42.

Thieme Becker

U. Thieme and F. Becker,
*Allgemeines Lexikon der Bildenden
Künstler*, 1908–50.

Waagen, *Supplement*, 1857

G. F. Waagen, *Treasures of art in
Great Britain, Supp.*, 1857.

Explanation of Terms

ATTRIBUTION: The following terms are used –
 Ascribed to: indicates an element of doubt in the attribution
 Workshop of: is only used for objects of furniture, such as *cassoni* (marriage chests)
 Follower of: indicates a work painted within a generation of the artist concerned
 After: is used where the precise original is identified
 Manner of: indicates a general stylistic relationship; usually a much later work.

MEDIUM: The medium is assumed to be oil unless otherwise stated.

MEASUREMENTS: These are given in inches followed by centimetres; height precedes width.

ARTISTS' BIOGRAPHIES: These have, in the main, been kept very brief. The principal monographs are sometimes listed, in particular where they do not appear in the catalogue entries.

2

Catalogue

Carl ADLOFF (1819–53)
German (Düsseldorf) School
Born in Düsseldorf, where he lived, he painted landscapes in the Dutch manner.

1
RIVER, WITH BOATS AND SHIPPING
Signed and dated lower left
C. Adloff 1861
Canvas
36 × 58 (91·4 × 147·3)
517–1870

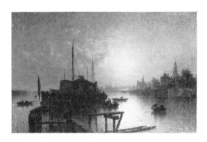

Prov. John Parsons; bequeathed to the Museum in 1870.

2
RIVER, WITH MOONLIGHT EFFECT
Signed and dated lower left
C. Adloff 1859
Canvas
27 × 45 (68·6 × 114·3)
518–1870

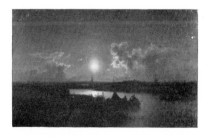

Prov. John Parsons; bequeathed to the Museum in 1870.

3
RIVER, WITH FISHING BOATS
Signed and dated lower left
C. Adloff 1859
Canvas
27 × 43 (68·6 × 109·2)
523–1870

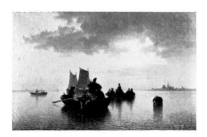

Prov. John Parsons; bequeathed to the Museum in 1870.

José Jimenes ARANDA (1837–1903)
Spanish (Seville) School
Born in Seville, where he was a pupil and subsequently professor at the
Academy of Art, he was a successful book illustrator as well as a painter.
He exhibited mainly genre scenes, receiving medals at exhibitions in
Madrid, Paris, Vienna, Munich, Berlin and Chicago.

4
WASHERWOMEN DISPUTING
Signed and dated lower centre
J. Ximenes y Aranda Seva. 1871
Canvas
18⅝ × 27½ (47·3 × 69·9)
Dixon Bequest
1065–1886

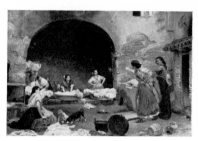

Prov. Joshua Dixon; bequeathed to Bethnal Green Museum in 1886.

Knud Andreassen BAADE (1808–79)
Norwegian School; worked in Germany
Born at Stavanger, he studied at the Copenhagen Academy from 1825
and then settled in Christiana (Oslo) as a portrait painter, 1829–31.
Subsequently he took up landscape painting and travelled extensively in
northern Norway. In 1836–39 he was in Dresden as the pupil of his
compatriot J. C. C. Dahl. He returned to Dresden in 1843–45 and then
settled in Munich, where he remained until his death. With his moonlight
landscapes of the Norwegian coast he achieved an international reputation.

5
THE WRECK
Canvas
35 × 46¾ (88·9 × 118·7)
Townshend Bequest
1555–1869

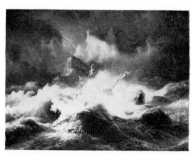

Condition. The paint surface is marred by an extensive network of deep cracks.
Prov. The Rev. C. H. Townshend; bequeathed to the Museum in 1868.

6
VESSEL IN THE MOONLIGHT
Canvas
21¾ × 32½ (55·5 × 82)
Townshend Bequest
1579–1869

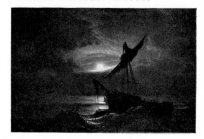

Prov. The Rev. C. H. Townshend; bequeathed to the Museum in 1868.

Hermann BAISCH (1846–94)
German School
Born in Dresden, he studied at the school of art in Stuttgart and then went
to Paris in 1886, where he was influenced by 17th century Dutch paintings
and by the Barbizon School. In 1869 he moved to Munich and began
painting more naturalistic landscapes. He became professor at the Karls-
ruhe Academy in 1881.

7
HORSES AND CATTLE IN A STORM
Signed lower left *H. Baisch*
Canvas
41¼ × 33½ (104·7 × 75·1)
Dixon Bequest
1081–1886

Prov. Joshua Dixon; bequeathed to Bethnal Green Museum in 1886.
Lit. Shaw Sparrow, 1892, p. 160.

August BAUER
German School
Active in Munich in the third quarter of the 19th century.

8
THE HALT OF THE TRAVELLERS:
SOLDIERS IN 17TH CENTURY COSTUME
Signed lower left *Aug Bauer München*
Canvas
15½ × 20 (39·3 × 50·8)
Townshend Bequest
1608–1869

Prov. The Rev. C. H. Townshend; bequeathed to the Museum in 1868.

Charles BAUGNIET (1814–86)
Belgian School
Born in Brussels and a student at the Academy there, he became a pro-
fessional painter and lithographer c. 1833. In 1841 he was in London, where
he became a very popular portrait painter. He subsequently lived in Paris
and Brussels.

9
THE SEAMSTRESS
Signed and dated lower left
C. Baugniet 1858
Panel
$20\frac{1}{2} \times 15\frac{1}{2}$ ($52\cdot1 \times 39\cdot3$)
Townshend Bequest
1564–1869

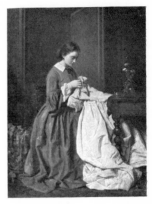

Prov. The Rev. C. H. Townshend; bequeathed to the Museum in 1868.

Charles Jules Nestor BAVOUX (1824–87)
French School
A landscape painter, he was a pupil at the École des Beaux Arts in Paris.
He lived in Paris and at Besançon and exhibited at the Salon from 1859 to
1882.

10
BESANÇON
Signed and dated lower right
Bavoux 1864
Canvas
$21\frac{1}{4} \times 32$ ($54 \times 81\cdot3$)
Townshend Bequest
1620–1869

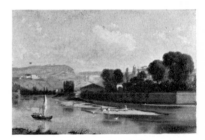

Prov. The Rev. C. H. Townshend; bequeathed to the Museum in 1868.

Georges BELLENGER (1847–1915)
French School
Born at Rouen, he was a pupil of Lecoq du Boisbaudran and Jules Laurens,
exhibiting at the Salon from 1864. He visited London in 1869. He painted
mainly portraits and still-life subjects and was well-known as a litho-
grapher.

11
PORTRAIT GROUP OF EUTERPE, ALEC
AND COTZ IONIDES
Signed and dated lower right
Georges Bellenger 1869
Canvas
$46\frac{5}{8} \times 55\frac{3}{8}$ ($118\cdot4 \times 140\cdot7$)
Ionides Bequest
CAI.1151

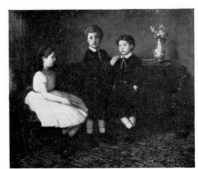

These are the three oldest of the eight children of Constantine Alexander Ionides and his wife Agathonike (*née* Fenerli). Euterpe, born in 1862, married W. F. Craies, of the Inner Temple, in 1880. There is another portrait of her in the Museum, painted in 1881 by G. F. Watts (CAI.1143). Alexander Constantine, 'Alec', born in 1862, was the author of the family history published in 1927 (see *Lit.* below). Constantine Albert, 'Cotz', was born in 1863 and died in 1916.

In his book (pp. 14, 19 f.) Alexander Ionides describes the family's move from Greece to England in 1864 and his life at 8 Holland Villas Road, where the picture was painted. The velvet knickerbockers are also affectionately described.

Prov. Painted for Constantine Alexander Ionides; bequeathed to the Museum in 1900.
Lit. Long, *Cat. Ionides Coll.*, 1925, p. 3; A. C. Ionides junior, *Ion: a grandfather's tale*, Dublin, 1927, *Notes and index*, privately printed 1927, p. 41.

José BENLLIURE y Gil (1855–after 1914)
Spanish School
Born at Cañamelas (Prov. Valencia), he studied at the Valencia Academy. Most of his life he spent at Rome as director of the Spanish Academy there, but he exhibited at the Madrid Academy continuously from 1875. He earned a considerable reputation as a painter of historical scenes and costume pieces and exhibited in London, Paris, Berlin and Munich as well as in Spain.

12
THE POSADA
Signed lower right *J. Benlliure*
Panel
9 × 13 (23 × 33)
P.23–1917

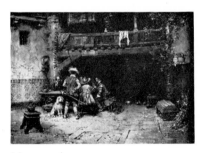

Prov. Henry L. Florence; bequeathed to the Museum in 1917.

Eugène de BLAAS (b. 1843)
Austrian: worked in Italy
Born at Albano, near Rome, he spent much of his life in Venice, where he was professor at the Academy. He painted mainly the fishermen of Venice and Murano and their families.

13
HEAD OF A BOY
Signed vertically on right side
Eugène de Blaas
Panel
10 × 7½ (25·4 × 19)
Dixon Bequest
1076–1886

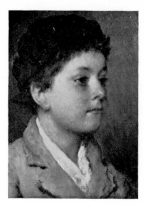

Prov. Joshua Dixon; bequeathed to Bethnal Green Museum in 1886.

Célestin BLANC (1818– ?88)
French School
Born at Celles (Isère), he was a pupil of Delaroche and Gleyre in Paris.
A painter of portraits, genre scenes and history subjects, he exhibited at the
Salon from 1844 to 1882.

14
HEAD OF A GIRL
Signed and dated on right
BLANC Ctin. 1867
Panel, grisaille
10½ × 8½ (26·7 × 21·6)
1034–1869

The contrast of the white face, dark dress and grey background seems
intended to resemble a photograph.

Prov. Bought at the exhibition listed below for £20.
Exh. Annual Exhibition, Palais de L'Industrie, Paris, 1867.

Gregor von BOCHMANN (1850–1930)
German (Düsseldorf) School
Born in Estonia, he studied in Reval and then in 1868 in Düsseldorf, where
he settled and where he became a professor at the Academy. He painted
landscapes and figure subjects.

15
FARM BUILDINGS WITH FIGURES,
SHEEP AND CATTLE
Signed and dated lower left
G. v. Bochmann 79
Panel
$11\frac{3}{8} \times 16\frac{7}{8}$ (28·9 × 42·8)
Dixon Bequest
1061–1886

Prov. Joshua Dixon; bequeathed to Bethnal Green Museum in 1886.
Lit. Shaw Sparrow, 1892, p. 160 ('a delightful little gem by G. Bochmann claims
all the attention that I can give . . .').

François Louis David BOCION (1828–90)
Swiss (Lausanne) School
Born at Lausanne, he was a pupil of Charles Gleyre and L. Grosclaude in
Paris. From 1849 he lived in Lausanne. He painted historical subjects in
his early years, but subsequently concentrated almost exclusively on
landscapes, in particular views of Lake Geneva.

There are sixteen paintings by Bocion in the bequest of the Rev. C. H.
Townshend, who was in the habit of spending the winter in Lausanne.

16
THE EMBARKATION: AN 18TH CENTURY
COSTUME PIECE
Signed and dated lower left
F Bocion 1848
Panel
$9\frac{1}{2} \times 13$ (24 × 33)
Townshend Bequest
1592–1869

Prov. The Rev. C. H. Townshend; bequeathed to the Museum in 1868.

17
LADIES IN CONVERSATION: AN 18TH
CENTURY COSTUME PIECE
Signed and dated lower left
1848 F Bocion
Panel
$12\frac{3}{4} \times 9\frac{1}{2}$ (32·3 × 24)
Townshend Bequest
1622–1869

Prov. The Rev. C. H. Townshend; bequeathed to the Museum in 1868.

18
LAKE GENEVA, WITH SAILING BOATS
Signed and dated lower right
F. Bocion 1855
Mill board
10 × 19¼ (25·4 × 49)
Townshend Bequest
1563–1869

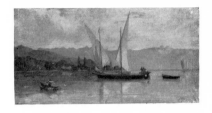

Prov. The Rev. C. H. Townshend; bequeathed to the Museum in 1868.

19
A BARGE
Signed and dated at the base of the
right-hand mast of the sailing boat
F. Bocion 1855
Mill board, painted surface oval
9 × 12¼ (23 × 31)
Townshend Bequest
1587–1869

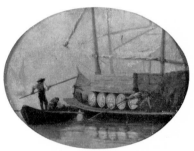

Prov. The Rev. C. H. Townshend; bequeathed to the Museum in 1868.

20
LUGGAGE BOAT
[On the back a charcoal sketch of a
seated man]
Signed and dated in the centre on a
board sticking up from the deck
1855 F. Bocion
Mill board, painted surface oval
9¼ × 12¾ (23·5 × 32·5)
Townshend Bequest
1594–1869

Prov. The Rev. C. H. Townshend; bequeathed to the Museum in 1868.

21
FISHING
Signed and dated lower left
F. Bocion 1855
Mill board
10¾ × 15 (27 × 38)
Townshend Bequest
1595–1869

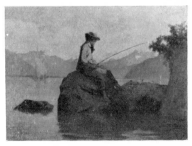

Prov. The Rev. C. H. Townshend; bequeathed to the Museum in 1868.

22
POULTRY
Signed and dated lower left
F. Bocion 1855
Canvas
$23\frac{1}{2}$ × $18\frac{3}{4}$ (60 × 47·5)
Townshend Bequest
1584–1869

Prov. The Rev. C. H. Townshend; bequeathed to the Museum in 1868.

23
THE REV. TOWNSHEND'S DOG
Signed and dated lower right
F. Bocion 1855
Canvas
$23\frac{1}{2}$ × $19\frac{1}{4}$ (60 × 44)
Townshend Bequest
1621–1869

This dog – a King Charles spaniel by the name of Bully – makes several appearances in the correspondence of Charles Dickens, who knew Townshend from 1840. In a letter of 1856 to Wilkie Collins, Dickens, in Paris, described a visit from Townshend: 'This Bully disconcerted me a great deal' (K. Robinson, *Wilkie Collins*, 1951, p. 99). On 1 February 1859 he wrote in a letter to Cerjat: 'To pass . . . to Townshend . . . let me report him severely treated by Bully who rules him with a paw of iron' (*The letters of Charles Dickens*, ed. G. Hogarth & M. Dickens, 1893, p. 476). Indeed, Dickens never became reconciled to Bully: on 3 May 1860, in another letter to Cerjat, he described the dog as 'old upon his legs and of a most diabolical turn of mind' (*ibid.*, p. 497).
Prov. The Rev. C. H. Townshend; bequeathed to the Museum in 1868.

24
STEAMER ON LAKE GENEVA; EVENING
EFFECT
Signed lower right *F. Bocion 1863*
Canvas
$13\frac{1}{4}$ × $29\frac{3}{4}$ (33·6 × 75·5)
Townshend Bequest
1591–1869

Prov. The Rev. C. H. Townshend; bequeathed to the Museum in 1868.

25
FEEDING DUCKS
Signed lower left *F. Bocion*
Canvas
$14\frac{3}{8} \times 11\frac{1}{8}$ (36·5 × 28)
Townshend Bequest
1585–1869

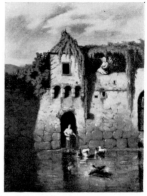

Prov. The Rev. C. H. Townshend; bequeathed to the Museum in 1868.

26
BIRD CATCHING
Signed lower right *F. Bocion*
Canvas
$16 \times 12\frac{3}{4}$ (40·5 × 32·5)
Townshend Bequest
1586–1869

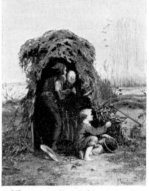

Prov. The Rev. C. H. Townshend; bequeathed to the Museum in 1868.

27
SAILING BOAT
Signed lower left *F. Bocion*
Cardboard
$8\frac{1}{8} \times 11\frac{1}{2}$ (20·5 × 29)
Townshend Bequest
1588–1869

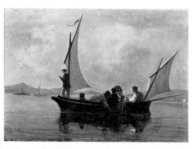

Prov. The Rev. C. H. Townshend; bequeathed to the Museum in 1868.

28
LANDSCAPE: THE SHORE OF A LAKE,
WITH FIGURES
Signed lower right *Bocion*
Mill board, oval
$7\frac{1}{2} \times 9\frac{1}{2}$ (19 × 24·1)
Townshend Bequest
1589–1869

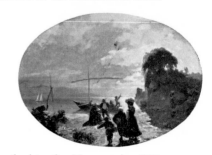

Prov. The Rev. C. H. Townshend; bequeathed to the Museum in 1868.

29
SAILING BOAT AND ROWING BOAT
Signed lower left *F. Bocion*
Mill board
$8\frac{3}{4} \times 12$ (22·2 × 30·5)
Townshend Bequest
1590–1869

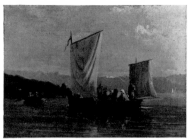

Prov. The Rev. C. H. Townshend; bequeathed to the Museum in 1868.

30
HAULING THE BOAT
Signed lower left *F. Bocion*
Mill board
$8\frac{1}{4} \times 17\frac{7}{8}$ (21 × 37·8)
Townshend Bequest
1593–1869

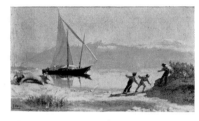

Prov. The Rev. C. H. Townshend; bequeathed to the Museum in 1868.

31
THE BROOM MAKER
Canvas on mill board
$14 \times 11\frac{1}{2}$ (35·5 × 29)
Townshend Bequest
1623–1869

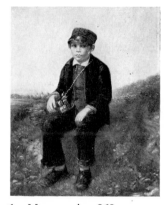

Prov. The Rev. C. H. Townshend; bequeathed to the Museum in 1868.

Follower of F. L. D. BOCION

32
LAKE SCENE
Canvas
$10\frac{7}{8} \times 18\frac{1}{8}$ (27·6 × 46)
Townshend Bequest
1613–1869

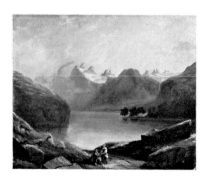

Acquired as 'artist unknown', this painting is close to Bocion in style, though not strictly comparable in quality.

Prov. The Rev. C. H. Townshend; bequeathed to the Museum in 1868.

Auguste François BONHEUR (1824–84)
French School
The brother of Rosa Bonheur (1822–99), he was born in Bordeaux, where he was a pupil of his father Raymond and of the École des Beaux-Arts. From 1845 he exhibited at the Paris Salon, at first portraits and then, from the 1850s, mainly landscapes.

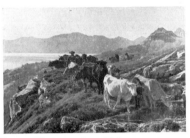

33
HIGHLAND SCENE WITH CATTLE
Signed and dated right of centre in foreground *Aug^{te} Bonheur. 1863*
Canvas
52 × 79¼ (132 × 201·3)
Dixon Bequest
1062–1886

Prov. Joshua Dixon; bequeathed to Bethnal Green Museum in 1886.
Lit. Shaw Sparrow, 1892, p. 158, repr.

A. BONIFAZI (active c. 1875)
Italian School
Worked in Rome; exhibited a figure subject at Suffolk Street in 1876, but is otherwise unrecorded.

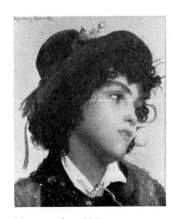

34
HEAD OF AN ITALIAN BOY
Signed and dated upper left
A. Bonifazi Roma 75
Panel
8½ × 7¼ (21·6 × 18·4)
Dixon Bequest
1073–1886

Prov. Joshua Dixon; bequeathed to Bethnal Green Museum in 1886.

François BONNET (1811-94)
French School: worked in Switzerland
Born at S. Marcellin (Isère), he studied in Paris, and then, for six years, in Rome. In 1848 he settled in Lausanne and then in 1862 in Freiburg, Switzerland, where he lived for the rest of his life. He painted mainly landscapes.

35
THE PANTHEON, ROME
Canvas, corners rounded
$11\frac{7}{8} \times 9\frac{1}{4}$ (30 × 24)
Townshend Bequest
1597-1869

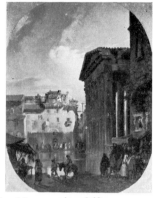

Prov. The Rev. C. H. Townshend; bequeathed to the Museum in 1868.

François Antoine BOSSUET (1798-1889)
Belgian School
Born at Ypres, he lived mainly in Brussels, where he was a pupil and subsequently professor of perspective (1832-79) at the Academy. He travelled extensively in Europe and specialized in architectural views.

36
ORIENTAL LANDSCAPE WITH CARAVAN
Signed lower right *F. Bossuet*
Canvas
$32\frac{1}{2} \times 51\frac{1}{4}$ (82·5 × 130)
Dixon Bequest
1069-1886

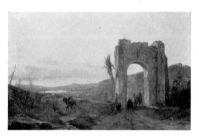

Prov. Joshua Dixon; bequeathed to Bethnal Green Museum in 1886.

37
CORDOVA, SPAIN
Signed and dated lower right
F. Bossuet 1863; inscribed, centre
foreground *CORDOVA*
Canvas
$31\frac{3}{4} \times 50\frac{1}{4}$ (80·6 × 127·6)
Dixon Bequest
1071-1886

Prov. Joshua Dixon; bequeathed to Bethnal Green Museum in 1886.

Henri de BRAEKELEER (1840–88)
Belgian (Antwerp) School

Born in Antwerp, where he was the pupil of his uncle H. Leys, he became one of the best known painters of the 19th century Belgian School, obtaining gold medals at the Brussels exhibition of 1872 and the universal exhibition in Vienna in the following year. He painted genre scenes, some of them in the manner of Pieter de Hooch.

Lit. A. de Ridder, *Henri de Braekeleer*, Brussels, 1931; P. Haesaerts, *Henri de Braekeleer*, Brussels, 1943; C. Conrardy, *Henri de Braekeleer*, Brussels, 1957.

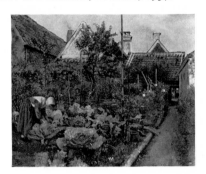

38
A FLEMISH GARDEN: LA COUPEUSE DE CHOUX
Signed lower right
Henri de Braekeleer
Canvas
18¾ × 23 (47·6 × 58·4)
Ionides Bequest
CAI.88

Two paintings very similar in style and subject, entitled *Le Jardin du Fleuriste*, are in the Museums at Antwerp and Tournai (Haesaerts, *op. cit.*, pl. vii, 1–2). Both are dated 1864. An etching after CAI.88, *La Coupeuse de Choux*, was also in the Ionides bequest (CAI.566; L. Delteil, *Le peintre-graveur illustré*, xix, 1925, no. 55).

Condition. Cleaned in 1958.
Prov. Constantine Alexander Ionides; bequeathed to the Museum in 1900.

Jacques Raymond BRASCASSAT (1804–67)
French School

Born at Bordeaux, he won a prize for landscape painting at the Paris Salon in 1825 and thereafter travelled in Italy. From 1835 he painted mainly animals in the manner of 17th century Dutch artists such as Paulus Potter.

39
A BULL IN A NORMANDY PASTURE
Stamped lower left
H.BRASCASSAT. DON H.
KRAFFT
Canvas
15½ × 13¾ (39·3 × 34·9)
298–1886

Prov. Hugues Krafft; given to the Museum in 1886.

Henriette BROWNE (pseudonym for Mme Jules de Saux) (1829–1901)
French School
Born in Paris, where she was a pupil of Perin and Chaplin, she painted
mainly portraits and genre scenes, particularly of children. She exhibited
regularly in the Paris Salon from 1853 and obtained prizes in 1861 and
1862.

40
INTERIOR: A GIRL WRITING AT A
TABLE
Signed, lower right *H*^tte *Browne*
Canvas
28 × 35⅝ (71·1 × 89·8)
Dixon Bequest
1083–1886

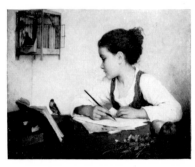

Prov. Joshua Dixon; bequeathed to Bethnal Green Museum in 1886.
Lit. Shaw Sparrow, 1892, p. 161 (engraved by Jonnard).

Jean BRYNER (1816–1906)
Swiss School
Born at Basserdorf near Zurich, he lived mainly in Lausanne. He was a
painter and etcher of Swiss landscape views.

41
LANDSCAPE: SCENE IN A VALLEY
Signed lower right *J. BRYNER*
Mill board
4¾ × 7⅜ (12 × 18·5)
Townshend Bequest
1626–1869

Prov. The Rev. C. H. Townshend; bequeathed to the Museum in 1868.

42
LANDSCAPE: DISTANT VIEW OF
LAUSANNE
Mill board
4¾ × 7⅜ (12 × 18·5)
Townshend Bequest
1627–1869

Prov. The Rev. C. H. Townshend; bequeathed to the Museum in 1868.

3

Alexandre CALAME (1810–64)
Swiss School

Born at Vevey, he became a pupil of Diday in Geneva. He received gold medals at the Paris Salons of 1837 and 1838. In the following year he visited Germany and Holland together with Hornung and in 1845 he was in Italy. After his return he lived in Switzerland, painting Alpine scenery particularly in the Bernese Oberland and at the Lake of the Four Cantons.

Lit. E. Rambert, *Alexandre Calame*, Paris, 1884; A. Schreiber-Favre, *Alexandre Calame*, Geneva, 1934.

43
LAKE OF THE FOUR CANTONS (LAKE
LUCERNE), NEAR BRUNNEN
Signed lower left *A Calame Genève*
Canvas
55¼ × 42½ (140·3 × 107·9)
Townshend Bequest
1554–1869

Listed under the year 1852 in Calame's order book (Rambert, no. 276). Another version of this composition (Rambert, no. 267) was lithographed by Calame.

Prov. Bought by the Rev. C. H. Townshend from the artist in 1852; bequeathed to the Museum in 1868.

Lit. Rambert, *op. cit.*, p. 551, no. 276: *Lac de Quatre-Cantons (dupl. du no. 267[?]) 108 sur 140 – M. Tornshind* [sic] *Angleterre.*

44
STUDY FROM NATURE: NEAR
VILLENEUVE
Inscribed lower left *Etude-d'après nature. A. Calame*
Canvas
9 × 15½ (23 × 40)
Townshend Bequest
1607–1869

Listed under the year 1855 in Calame's order book (Rambert, no. 329), this is one of the very few of his studies from nature sold by him in his lifetime. Most of his sketches were sold at the posthumous sale at the Hôtel Drouot, Paris, 12–21 March 1865.

Calame's sketches from nature, which may be compared with those of the Barbizon School, have found greater favour among some 20th century critics than his more romantic finished works (see for example, Schreiber-Favre, *op. cit.*, p. 39).

Prov. Bought by the Rev. C. H. Townshend from the artist in 1855; bequeathed to the Museum in 1868.

Lit. Rambert, *op. cit.*, p. 554, no. 329: *Environs de Villeneuve Etude (1855) 40 sur 23 cm. – M. Townshend, anglais.*

Jacques François CARABAIN (b. 1834)
Belgian School
Born in Amsterdam, where he studied at the Academy, he subsequently settled in Brussels and acquired Belgian nationality in 1880. He painted landscape and architectural subjects in Belgium, Germany, France and Italy.

45
CHRISTENING PARTY AT BACHARACH, GERMANY
Signed lower right *J. Carabain*
Canvas
30¼ × 24½ (76·8 × 62·2)
628–1901

Prov. Sir Edwin Durning-Lawrence, Bt; given to the Museum in 1901.

L. CARACCIOLO (active first half 19th century)
Italian School
Recorded primarily as an engraver.

46
PANORAMA OF ROME
Signed, and dated lower left
L. Caracciolo Roma 1824
Canvas
5 ft 6 in. × 43 ft 10 in.
(167·7 × 1335·8)
1292–1886
Not reproduced

The term 'panorama' was used from about 1790 to describe a circular painting shown so that the spectator, standing on a platform in the middle, could encompass the whole by turning a full 360 degrees. The illusion of reality was maintained, because the spectator could see nothing except the panorama within the rotunda built specially for displaying works of this kind. In this example the two extremities – on the right St Peter's, on the left the Forum and the Colosseum – were presumably joined together. An engraved key entitled *Panorama des Environs de Rome*, which was received with the painting, does not appear to tally with it in detail.

The first patent of a panorama was taken out in 1787 by Robert Barker, an otherwise little-known painter from Edinburgh. In 1787–88 he showed

his first panorama, a *View of Edinburgh*, at Holyrood and Glasgow and subsequently, in 1789, at 28 the Haymarket, London. In 1800 panoramas were established in Paris and Berlin and they remained popular until well into the second half of the 19th century.

A *Panorama of Rome* was shown at the Colosseum in Regents Park (built by Decimus Burton in 1824–29) not long after its opening in the late 1820s, but, apart from the coincidence in date, there is no evidence that this panorama may be identified with 1292–1886 (see G. Bapst, *Essai sur l'histoire des panoramas et des dioramas*, 1891, p. 27).

Condition. The canvas has worn through in several places, but on the whole the condition is reasonably good.

Prov. The Rev. Sir V. D. Vyvyan, Bt; given to the Museum in 1886.

Alessandro CASTELLI (1809–1902)
Italian School
Castelli was born in Rome, where he was a student at the Accademia di S. Luca and where he exhibited from 1836. Exiled from Rome in 1859, he lived first in Paris, and, from 1864, in England. In 1870 he again settled in Rome.

47
Rocky Italian landscape
Canvas
$38\frac{1}{4} \times 63\frac{1}{8}$ (96 × 166·3)
Dixon Bequest
1070–1886

Prov. Joshua Dixon; bequeathed to Bethnal Green Museum in 1886.

Vincent-Jean-Baptiste CHEVILLIARD (1841–1904)
French School
Born of French parents in Frascati, he studied at the École des Beaux-Arts in Paris from 1865. He exhibited in the Paris Salon from 1865 until 1905, specializing in humorous genre scenes.

48
The cure's story: two priests
seated at a table
Signed lower right *V. Chevilliard*
Panel
$5\frac{7}{8} \times 5\frac{1}{4}$ (15 × 13·3)
Dixon Bequest
1077–1886

Prov. Joshua Dixon; bequeathed to Bethnal Green Museum in 1886.
Lit. Shaw Sparrow, 1892, p. 159, repr. p. 164.

Paul Jean CLAYS (1819–1900)
Belgian School
Born in Bruges, he was a pupil of Horace Vernet and Théodore Gudin in Paris, and settled as a painter in Antwerp (1839–56) and subsequently in Brussels. He specialized in scenes of the Belgian and Dutch coast, which, from 1851, he treated in a broader and freer style. Through his exhibits at the International Exhibitions of 1867 and 1878 in Paris, he achieved an international reputation.

49
ROCKY COAST WITH FIGURES AND BOATS
Signed and dated lower right
P. J. Clays 1855
Canvas
23¾ × 37½ (60·3 × 95·2)
Townshend Bequest
1578–1869

Prov. Presumably acquired by the Rev. C. H. Townshend not long after it was painted; bequeathed by him to the Museum in 1868.

Jules CORNILLIET (1830–86)
French School
A painter of genre and history subjects, he was a pupil of Ary Scheffer and Horace Vernet. From 1857 he exhibited regularly at the Paris Salon and in 1870 at the R. A.

50
GIRLS AT A WELL
Signed and dated lower right
J. Cornilliet 1867
Canvas
32¾ × 23 (84·2 × 58·4)
1035–1869

Prov. Bought by the Museum in 1867.

Jean Baptiste Camille COROT (1796–1875)
French School
Born in Paris, he began painting full-time in 1822, studying with the classicizing landscape painters Achille Michallon and Victor Bertin. He worked out of doors in Fontainebleau and elsewhere until his visit to Italy in 1825–28, which transformed his style. He visited Italy again in 1834 and 1843 but most of the rest of his life was spent in Paris and its environs and at Fontainebleau, where, from the turn of the mid-century, he frequently met the artists of the Barbizon group. His style remained a mixture of Italian classicism and Barbizon realism. He exhibited in the Salon from 1827, gradually achieved recognition, receiving official commissions from the 1840s and being made a Chevalier of the Legion of Honour in 1846.

Lit. A. Robaut and E. Moreau-Nelaton, *L'oeuvre de Corot*, Paris, 1905; G. Bazin, *Corot*, rev. ed., Paris, 1951.

51
TWILIGHT: LANDSCAPE WITH TALL
TREES AND FEMALE FIGURE
Signed lower left *COROT*
Canvas
16½ × 11½ (42 × 29)
Ionides Bequest
CAI.65

This could well be identical with *Le Soir au Vallon*, Robaut, ii, p. 378 f, no. 1205, 40 × 29 cm., which belonged to Durand-Ruel in 1876, but it is stated to have been signed on the right-hand side. Whether this identification can be upheld or not, the date assigned by Robaut to no. 1205, c. 1855–60, can well be applied to this painting also.

Condition. The surface is covered by network of thin white cracks.
Prov. Apparently acquired by Constantine Alexander Ionides between 1884 and 1889; bequeathed to the Museum in 1900.
Exh. French and Dutch Romanticists, Dowdeswell Galleries, 1889, no. 36.
Lit. Cf. A. Robaut, *L'oeuvre de Corot*, ii, 1905, p. 378 f., no. 1205; Sir C. Holmes in *Burl. Mag.*, vi, 1904–05, p. 31, repr.; Long, *Cat. Ionides Coll.*, 1925, p. 12; V.&A. Museum, *The Barbizon School*, 1965, p. 15, pl. 1.

52
MORNING: LANDSCAPE WITH TWO
COWS AND A FIGURE
Signed lower left *COROT*
Canvas
7⅛ × 9⅛ (18 × 23·2)
Ionides Bequest
CAI.66

Both style and subject fit most convincingly in the period c. 1855–65.

Prov. Apparently acquired by Constantine Alexander Ionides after 1884; bequeathed to the Museum in 1900.

Lit. Sir C. Holmes in *Burl. Mag.*, vi, 1904–05, p. 27, repr. p. 33; Anon. in *Athenaeum*, 23 July 1904, p. 119; Long, *Cat. Ionides Coll.*, 1925, p. 12, pl. 7; V. & A. Museum, *The Barbizon School*, 1965, p. 15, pl. 2.

Manner of COROT

53
LANDSCAPE: WOODLAND STUDY
Inscribed lower right *COROT*
Mahogany panel
$7\frac{1}{4} \times 5\frac{3}{8}$ (18·5 × 13·6)
P.25–1917
Not reproduced

Acquired as by Corot, this appears to be an imitation.

Prov. Bought by Henry L. Florence from Thomas McLean; bequeathed to the Museum in 1917.

Gustave COURBET (1819–77)
French School
Born at Ornans (Doubs), he went to Paris in 1840. Although he attended the Atelier Suisse, he was largely self-taught as an artist. He painted portraits, landscapes and scenes from country life in a very realistic manner and became the acknowledged leader of the 19th century realists in painting. From 1844 he exhibited in the Salon. He joined the Commune in 1871 and was sentenced to six months' imprisonment for having been implicated in the destruction of the Colonne Vendôme. In 1873 he settled in Switzerland, where he died.

Lit. G. Riat, *Gustave Courbet*, Paris, 1906; G. Mack, *Gustave Courbe* 1951.

54
L'IMMENSITÉ
Signed and dated lower left
69 G. Courbet
Canvas
$23\frac{5}{8} \times 32\frac{3}{8}$ (60 × 82·2)
Ionides Bequest
CAI.59

A smaller version with minor variations (49 × 54 cm.) belonged to Serge Morin in the 1940s and, c. 1950, to Mme Katia Granoff. A painting of the same subject, treated differently in detail, is in the Bristol City Art Gallery (*L'Eternité*, 64·7 × 79·3 cm.; *Catalogue of oil paintings*, 1957, p. 98, pl. 62).

Prov. Henri Hecht; c. 1884–86, Constantine Alexander Ionides; bequeathed to the Museum in 1900.

Exh. Courbet, École des Beaux Arts, Paris, 1882, no. 110 (*Marée basse, soleil couchant*, lent by Henri Hecht); *French and Dutch Loan Collection*, Edinburgh International Exhibition, 1886, no. 1086 (no. 21 of *Mem. cat.*; lent by C. A. Ionides); *French and Dutch Romanticists*, Dowdeswell Galleries, 1889, no. 111; Winter Exhibition, R. A., 1896, no. 50; *Pictures of the French School*, Corporation of London Art Gallery, Guildhall, 1898, no. 143; *The modern French School*, Birmingham Art Museum, 1898, no. 7.

Lit. Review of Winter Exhibition, R. A., in *Athenaeum*, 15 Feb. 1896, p. 223; A. Estignard, *Courbet, sa vie, ses oeuvres*, 1896, p. 166 (wrongly still given as belonging to H. Hecht); Sir C. Holmes in *Burl. Mag.*, vi, 1904–05, p. 27, pl. iv; F. Rutter in *L'Art et les Artistes*, v, 1907, p. 10, repr. p. 12; Long, *Cat. Ionides Coll.*, 1925, p. 13, pl. 8; C. Leger, *Courbet*, Paris, 1929, pl. 54; *ibid.*, *Courbet et son temps*, Paris, 1948, fig. 40.

55
Landscape, with the Chatel St. Denis, Scey-en-Varais (Doubs)

Signed and dated lower left

73 G. Courbet

Canvas

26 × 31¾ (66 × 80·6)

Ionides Bequest

CAI.60

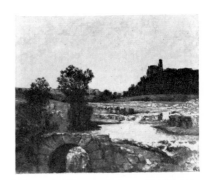

The subject was identified by Gaston Delastre, Conservateur du Musée d'Ornans (letter to the Department, 22 Oct. 1953). The Chatel St Denis, Scey-en-Varais, is 9 km. from Courbet's home at Ornans. A view of the Chatel from the other side of the valley is in the Musée d'Art et d'Histoire, Geneva.

Prov. Goupil & Co. (label at back); before 1884, Constantine Alexander Ionides; bequeathed to the Museum in 1900.

Exh. French and Dutch Romanticists, Dowdeswell Galleries, 1889, no. 110 (*A Rivulet*).

Lit. Monkhouse, 1884, p. 122 (where it is described as the only Courbet then in the collection); G. Geffroy, 'Gustave Courbet' in *L'Art et Les Artistes*, iv, 1906–07, p. 261, repr.

Alfred DE DREUX (1810–60)

French School

Born in Paris, where he was a pupil of L. Cogniet, he exhibited at the Salon from 1831 and became a successful painter of elegant equestrian scenes. After the Revolution of 1848 he came to London with Lami and Gavarni and remained there until 1859, when he was commissioned to paint an equestrian portrait of Napoleon III. He died as a result of a duel in 1860.

56
A SCOTTISH GIRL
Signed lower left *Alfred De Dreux*
Canvas
36 × 28¼ (91·4 × 71·7)
744–1902

Presumably painted during the period of De Dreux's residence in London (1848–59).
Prov. F. R. Bryan; presented to the Museum in 1902.

57
A FAIR EQUESTRIAN
Signed lower left *Alfred DD*
Canvas
18⅞ × 13⅞ (47·9 × 35·2) [incl. later increase of ¾ in. on each of the four sides]
745–1902

Elegant women on horseback, usually entitled *Une Amazone*, were De Dreux's favourite subjects. For comparable works see, for example, sales: Drouot, Paris, 17 Nov. 1948, lot 85, and Christie's, 6 Dec. 1963, lot 88; *Country Life*, 8 Oct. 1959.
Condition. Cleaned in 1959.
Prov. F. R. Bryan; presented to the Museum in 1902.
Lit. V. & A. Museum, *French paintings*, 1971, pl. 30.

Hilaire Germain Edgar DEGAS (1834–1917)
French School
Born in Paris, the son of a wealthy banker, he first studied law at his father's wish. In 1855 he took up painting and went to classes at the École des Beaux-Arts. He went to Italy in 1856–57 and on his return painted history subjects. The influence of Ingres dominated his student years but from about 1865 this was replaced by that of Manet, whose friend he had become. In the war of 1870–71 he was in the artillery and a year later he visited the U.S.A. He exhibited at seven of the eight Impressionist

Exhibitions held between 1874 and 1886, but open-air landscape painting never played a predominant role in his work as it did in that of the Impressionists. In the second half of his career he concentrated on painting ballet dancers in pastel and oil.

58
THE BALLET SCENE FROM MEYERBEER'S
OPERA 'ROBERT LE DIABLE'
Signed lower left *Degas*
Canvas
29¾ × 32 (76·6 × 81·3)
Ionides Bequest
CAI.19

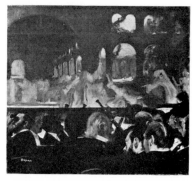

Meyerbeer's opera, which was first performed in Paris in November 1831, contains a scene dominated by the phantoms of nuns who in life had been unfaithful to their vows. They were conjured from their tombs by a mysterious character called Bertram, who intended to use them to bring about the ruin of his son Robert.

Degas devoted some two-thirds of the composition to showing the shadowy forms of the nuns on the stage; the foreground contains the orchestra and the front three rows of the stalls, effectively forming a group portrait of some of Degas' friends. Albert Hecht, the collector, appears on the extreme left holding his opera glasses; next but one to the right, in full profile, is Désiré Dihau, the bassoonist in the orchestra; the bearded figure seen from behind towards the right is the amateur painter Vicomte Lepic (for other portraits of these friends of the artist see J. S. Boggs, *Portraits by Degas*, University of California Press, 1962).

An earlier version, upright in format and with the stage taking up only about half of the composition, which was painted for Albert Hecht, is in the Metropolitan Museum, New York (H. O. Havemeyer Collection, 26 × 21⅜ in., Lemoisne, ii, 1946, no. 294). It is dated 1872 and therefore predates by four years the Museum's version, which was completed in 1876 for the baritone Jean-Baptiste Faure (*Letters*, 1947). The relationship of the two versions to each other and to similar compositions by Degas of this period is fully discussed by Jonathan Mayne (1966).

There are five brush drawings of nuns – presumably sketches for the 1872 version – in the Museum (E.3685/88–1919: three repr. by Browse, 1949, pls. 6–7; four by Mayne, 1966, figs. 4–7), and another drawing in a notebook in the Bibliothèque Nationale, Paris (T. Reff, *Burl. Mag.*, cvii, 1965, p. 614).

CAI.19, painted in 1876, was bought by Ionides in 1881 (the formerly prevalent view that it was bought by him in 1872 was based on a confusion with the New York version). It is, therefore, one of the earliest paintings by Degas to have been acquired by an English collector, though in this respect Ionides was preceded by Henry Hill and Louis Huth in the 1870s (Pickvance, 1963). It was, however, the first painting by Degas to enter an English museum: a work by him was not found acceptable by the N. G., even as a gift, as late as 1905 (Cooper, 1954, p. 67).

There is a copy of this painting by the American artist Everett Shinn entitled *La Favorita* (*Apollo*, lxxvii, 1963, p. 62, fig. 9).

Prov. 1876, Jean-Baptiste Faure; 28 Feb. 1881, Durand-Ruel; 7 June 1881, Constantine Alexander Ionides (see Pickvance, 1963); bequeathed to the Museum in 1900.

Lit. Degas letters, ed. M. Guérin, 1947, p. 45; Monkhouse, 1884, p. 126 f., repr. p. 121; Anon.,'The Constantine Ionides Collection' in *Art Journal*, 1904, p. 286, repr.; Sir C. Holmes in *Burl. Mag.*, v, 1904, p. 530, pl. iii; P. A. Lemoisne, *Degas*, 1912, pl. 13; L. Hourticq, 'E. Degas' in *Art et Décoration*, xxxii, 1912, p. 99, repr.; P. Jamot, *Degas*, 1924, p. 138, pl. 25; Long, *Cat. Ionides Coll.*, 1925, p. 19. pl. 11; J. B. Manson, *The life and work of E. Degas*, 1927, p. 19, pl. 4; G. Bazin, 'Degas et l'objectifs' in *L'Amour de l'Art*, xii, 1931, p. 306, fig. 101; P. A. Lemoisne, *Degas et son oeuvre*, ii, 1946, p. 210, no. 391; L. Browse, *Degas dancers*, 1949, p. 338, pl. 9; D. Cooper, *The Courtauld Collection*, 1954, p. 67; R. Pickvance, 'Degas Dancers 1872-6' in *Burl. Mag.*, cv, 1963, p. 266; J. Mayne, 'Degas's ballet scene from 'Robert le Diable' in *Victoria & Albert Museum Bulletin*, ii, 1966, pp. 148–56 (separately issued 1969.)

Heinrich DEITERS (1840-1916)
German (Düsseldorf) School
Born in Düsseldorf, where he was a pupil at the Academy and where he lived, he was a popular painter of naturalistic landscapes.

59
LANDSCAPE WITH FARM HOUSE
Signed and dated lower left
H Deiters (H and D in monogram)
60 Df (Düsseldorf)
Canvas
21¼ × 16¾ (54 × 42·5)
527–1870

Prov. John Parsons; bequeathed to the Museum in 1870.

Ferdinand Victor Eugène DELACROIX (1798–1863)
French School
Born near Paris, the son of a high government official, he became a pupil of
Guérin in 1815 and received instruction in water-colour painting from
Thales Fielding, with whom he lived for a time in Paris. He was influenced
by the work of Constable, exhibited at the Salon in 1824 and came to
England in 1825. In 1832 he visited Morocco. As the leading exponent of
Romantic painting, Delacroix met with much opposition, and it was not
until 1857 that he became a member of the Académie des Beaux-Arts. He
painted portraits, animals and religious, mythological, allegorical and
historical subjects.

60

THE GOOD SAMARITAN (ST LUKE, X,
34)
Signed and dated lower centre
Eug. Delacroix. 1852
Canvas
13¼ × 16½ (33·7 × 41·9)
Ionides Bequest
CAI.63

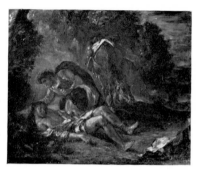

This is the second of two paintings by Delacroix of the Good Samaritan.
The first, a small upright composition of 1850, shows the Samaritan helping
the traveller to remount his horse (private collection Paris; Robaut 1885,
no. 1168; M. Serullaz, *Mémorial de l'Exposition Eugène Delacroix*, 1963,
no. 414, repr., and with full bibliography).

CAI.63 was painted in the early months of 1852 for the dealer Beugniet
(Delacroix Diary, 2 and 8 Feb. 1852). It shows the Samaritan coming
upon and tending the wounded traveller who had fallen among thieves.
The composition is traditional for this scene and there are many parallels
of the 16th and 17th centuries, for example, paintings by Jacopo Bassano
(Hampton Court), Ribera (Rouen Museum) and Jan Wijnants (Leningrad,
Hermitage, 1958 *Catalogue*, ii, no. 6758), and several drawings by
Rembrandt (W. R. Valentiner, *Rembrandt, Handzeichnungen*, K. d. K.,
i, 1925, figs. 373–75).

Condition. Good, apart from small hole in area of tree, upper right. Cleaned in 1957.
Prov. Vente A, Paris, 24 Apr. 1858, bought for 750 francs by M. G. Arosa (accord-
ing to Robaut); sold Arosa Sale, Paris, 25 Feb. 1878, for 5,000 francs to M.
Brame; 1878, M. Perrault; Goupil & Co. (label on back); before 1884, Constantine
Alexander Ionides; bequeathed to the Museum in 1900.
Exh. Exposition d'Eugène Delacroix, Société Nationale des Beaux-Arts, Paris, 1864,
no. 119 (lent by M. Arosa); *Exposition retrospective de tableaux et dessins des
maîtres modernes*, Durand-Ruel, Paris, 1878, no. 154 (lent by M. Perrault not
'Perreau'); *French and Dutch Loan Collection*, Edinburgh International Exhibition,
1886, no. 1143 (no. 39 of *Mem. Cat.*); *French and Dutch Romanticists*, Dowdeswell
Galleries, 1887, no. 99.

Lit. Journal de Eugène Delacroix, ed. A. Joubin, i, 1932, pp. 448, 450; Monkhouse, 1884, p. 38 f.; A. Robaut, *L'oeuvre complet de Eugène Delacroix*, 1885, no. 1191; Sir C. Holmes in *Burl. Mag.*, v, 1904, p. 531, repr.; Anon. in *Athenaeum*, July 1904, p. 119; V. & A. Museum, *French paintings*, 1949, pl. 20; R. Huyghe, *Delacroix*, 1963, p. 492 & fig. 369.

61
THE SHIPWRECK OF DON JUAN:
A SKETCH
Canvas
32 × 39¼ (81·3 × 99·7)
Ionides Bequest
CAI.64

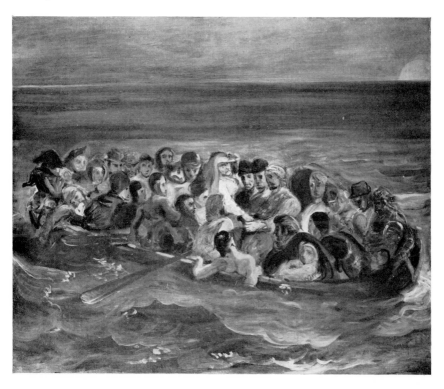

This painting illustrates the incident described in Byron's *Don Juan*, Canto II. Don Juan and his shipwrecked companions are drawing lots as to 'who should die to be his fellows' food':

> The lots were made, and mark'd and mix'd, and handed
> In silent horror'.

(Stanza 75)

It is a sketch for the *Naufrage de don Juan* in the Louvre (130 × 195 cm.) which was painted in 1840 and exhibited at the Salon in the following year·

There are also two pen drawings in the Louvre (RF 6743 and 9361) which are described and reproduced together with the large oil painting by M. Serullaz, *Mémorial de l'Exposition Eugène Delacroix*, 1963, p. 227 ff., nos. 303–05. This sketch differs from the final version principally in that the boat is much more crowded, but there are differences also in the background – particularly in the position and prominence of the sun – and in the treatment of the boat itself. An etching of it was made by Le Rat for Durand-Ruel (Robaut, 1885).

G. H. Hamilton ('Delacroix, Byron and the English Illustrators' in *Gazette des Beaux-Arts*, xxxvi (2), 1949, p. 271, figs. 12–3) suggested that the composition was derived from George Cruikshank's engraving in G. Clinton, *Memoirs of the life and writings of Lord Byron*, which was published in 1825, when Delacroix was in England. Hamilton compares five of Cruikshank's illustrations with Delacroix's compositions of Byronic subjects and there seems little doubt that the French painter was acquainted with Cruikshank's work. However, in this instance Cruikshank's composition, while generically similar, is not very close in detail to either this sketch or the final version. Shipwreck was a most popular subject in Romantic painting (see, for example, T. S. R. Boase in *J. W. C. I.*, xxii, 1959, p.332 ff.), and it seems likely that Delacroix was inspired by other sources as well as Cruikshank's engraving. The *Naufrage* had a well-known forerunner in Géricault's *Raft of the Medusa*, 1819, and Long pointed to similarities with Rowlandson's *Distress* (Girtin Collection; A. P. Oppé, *Thomas Rowlandson*, 1923, pl. 45), which was engraved and which also contains the figure of a man with his elbows on the gunwale. Huyghe (1963, pp. 464–69), discussing the theme of shipwreck, points out Delacroix's influence on later artists.

Delacroix himself painted several related compositions, in particular the *Naufragés abandonnés* (Robaut, no. 1473, 1821; and no. 1010, 1847) and *Christ on the Lake of Gennesaret* (Robaut, nos. 1214–20, 1853; now private collection, Zurich).

Prov. Probably identical with *La Barque de Don Juan; première pensée* sold at the posthumous sale of Delacroix's remaining works in 1864 (lot 140) for 1,500 francs to M. Haro; Durand-Ruel; Émile de Girardin (according to Robaut); sold Paris, 24 Feb. 1881, for 7,700 francs; before 1884, Constantine Alexander Ionides; bequeathed to the Museum in 1900.

Exh. Exposition d'Eugène Delacroix, Société Nationale des Beaux Arts, Paris, 1864, no. 123 (lent by M. Haro); *French and Dutch Loan Collection*, Edinburgh International Exhibition, 1886, no. 1098 (no. 40 of *Mem. Cat.*, repr. p. 26); *French and Dutch Romanticists*, Dowdeswell Galleries, 1889, no. 100.

Lit. 'Vente Eugène Delacroix' in *L'Artiste*, 1864, pl. i, p. 142; *Revue Universelle des Arts*, 1864, p. 137; *La Chronique des Arts*, 1881, p. 69 (account of sale of 24 Feb.); Monkhouse, 1884, p. 39; A. Robaut, *L'oeuvre complet de Eugène Delacroix*, 1885, no. 686 & p. 491 (though it is not, as he states, signed); *Memorial of the French and Dutch Loan Collection, Edinburgh International Exhibition 1886*, 1888 (repr. of a sketch of it by William Hole, R.S.A.); Sir C. Holmes in *Burl. Mag.*, v, 1904, p. 529; Anon., 'Additions to the National Collections' in *Athenaeum*, July 1904, p. 119; Long, *Cat. Ionides Coll.*, 1925, p. 21 f., pl. 12; V. & A. Museum, *French paintings*, 1949, pl. 21: R. Huyghe, *Delacroix*, 1963, p. 490, fig. 342.

Paul (actually Hippolyte) DELAROCHE (1797–1856)
French School
Born in Paris, he was a student at the École des Beaux Arts and also a pupil
of Watelet and Gros, from whom he learnt the art of history painting. From
1822 he exhibited at the Salon and subsequently became enormously
popular as a history painter.

62
St Cecilia and the angels
Signed and dated at the base of the
Saint's throne on the right
Paul DelaRoche. 1836
Canvas, upper corners cut off,
81 × 64 (205·7 × 162·5)
553–1903

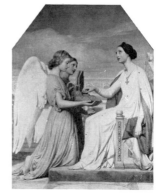

Mirecourt (1856) described this painting in glowing terms: 'C'est une
oeuvre d'une grâce exquise et d'une limpidité de coloris qui semble em-
pruntée à la palette de Giotto'. It was engraved by François Forster in 1841
(*L'Artiste*, 1841). Although the style of the painting betrays the influence of
Raphael and Domenichino, the composition is not very similar to their well
known representations of St Cecilia (respectively Bologna Pinacoteca and
San Luigi dei Francesi, Rome).

Prov. James Reiss; by descent to his daughter, Mrs Henry Jephson; given by her
to the Museum in 1903.
Exh. Paris Salon 1837.
Lit. 'Paul Delaroche, Saint Cécile' in *L'Artiste*, 2 s., vii, 1841, p. 8; E. de Mire-
court, *Paul Delaroche*, Paris, 1856, p. 41 f.

Eugène DELFOSSE (1825–65)
Belgian School
Resident in Brussels and Antwerp, he painted mainly history and genre
scenes. For briefer periods he lived in Paris and London, where he ex-
hibited at the R. A. from 1849 to 1861.

63
Interior with armed men and a
family group
Signed on right of window
E. DELFOSSE ANVERS 184[4 or 6]
Panel
23 × 30 (58·4 × 76·2)
1324–1871

Prov. Bought in 1871.

Narcisse Virgile DIAZ de la Peña (1808–76)
French School
Born of Spanish political refugee parents in Bordeaux in 1808, Diaz worked
as a porcelain painter in the early 1820s and then became the pupil of
François Souchon. He was first accepted in the Salon in 1831 and exhibited
there regularly from 1834. His most typical works of the 1830s and '40s
are Romantic subjects, such as oriental women, and *scènes galantes* derived
from the French 18th century tradition. He first met Rousseau in 1837 and
under his influence increasingly turned to landscape. From about 1850,
when landscapes begin to predominate in his output, he achieved his
mature landscape style, typified by forests and meadows sparkling with
light. In 1851 he was made a Chevalier of the Legion of Honour. His
closest follower was Monticelli, but in his use of small dabs of pigment to
convey the visual effects of light, he exercised a considerable influence on
the Impressionists.

64
GIRL WITH DOGS
Signed lower left *H. Diaz*
Panel
10¾ × 6½ (27·5 × 16·5)
Townshend Bequest
1535–1869

Girls with dogs, preferably in a forest, were frequently portrayed by Diaz,
particularly in the early part of his career, c. 1845–50.
Prov. The Rev. C. H. Townshend, bequeathed to the Museum in 1868.
Lit. V. & A. Museum, *The Barbizon School*, 1965, p. 17, pl. 7.

65
LA BAIGNEUSE
Signed lower left *H. Diaz*
Panel
9½ × 12⅞ (24·5 × 33)
Ionides Bequest
CAI.61

A closely related composition but with a different figure, *Woman wash-
ing at a stream* (panel 12½ × 15¾ in.), is in the York Art Gallery.
Prov. Acquired by Constantine Alexander Ionides before 1884; bequeathed to the
Museum in 1900.

Exh. French and Dutch Loan Collection, Edinburgh International Exhibition, 1886, no. 1142 (no. 47 of *Mem. Cat.*); *French and Dutch Romanticists*, Dowdeswell Galleries, 1889, no. 5.

Lit. Monkhouse, 1884, repr. p. 36; *Memorial of the French and Dutch Loan Collection, Edinburgh International Festival 1886*, 1888 (repr. of a sketch of it by William Hole, R.S.A.); A. Tomson, *Jean François Millet and the Barbizon School*, 1903, repr. facing p. 166; Sir C. Holmes in *Burl. Mag.*, vi, 1904, p. 27, repr. p. 33; Long, *Cat. Ionides Coll.*, 1925, p. 23; V. & A. Museum, *The Barbizon School*, 1965, p. 17, pl. 8.

66
VIEW IN FONTAINEBLEAU FOREST:
EVENING
Signed lower left *H. Diaz*
Panel
$6\frac{1}{4} \times 10\frac{1}{8}$ (15·8 × 25·7)
Ionides Bequest
CAI.62

Prov. Acquired by Constantine Alexander Ionides before 1886; bequeathed to the Museum in 1900.

Exh. French and Dutch Loan Collection, Edinburgh International Exhibition, 1886, no. 1162 (no. 54 of *Mem. Cat.*).

Lit. A. Tomson, *Jean François Millet and the Barbizon School*, 1903, repr. facing p. 156; Long, *Cat. Ionides Coll.*, 1925, p. 24; V. & A. Museum, *The Barbizon School*, 1965, p. 17, pl. 9.

67
LANDSCAPE
Signed lower left *H. Diaz*
Panel
12 × 19 (30·5 × 48·5)
Ionides Bequest
CAI.164

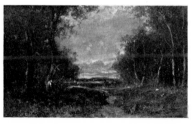

This type of landscape, with trees reaching to the top on either side and an open view of the sky in the centre, provides one of Diaz's favourite compositional schemes.

Prov. Acquired by Constantine Alexander Ionides after 1884; bequeathed to the Museum in 1900.

Lit. A. Tomson, *Jean François Millet and the Barbizon School*, 1903, repr. facing p. 156; V. & A. Museum, *The Barbizon School*, 1965, p. 18, pl. 10.

François DIDAY (1802–77)
Swiss School
Born in Geneva, he visited Italy and, in 1830, Paris and then settled in his native city. A successful painter, he exhibited widely, in Berlin (1838–40), London (R. A. 1842), and Paris as well as in Switzerland, and had many pupils. He painted mainly Alpine scenes.

68
STUDY FROM NATURE AT BEX
Signed lower left *F. Diday*
Canvas
$14\frac{1}{4} \times 19\frac{1}{4}$ (36·2 × 48·9)
Townshend Bequest
1582–1869

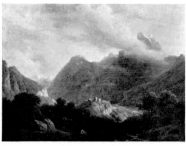

Prov. The Rev. C. H. Townshend; bequeathed to the Museum in 1868.

Hendrik DILLENS (1812–72)
Belgian School
Born in Ghent, he lived mainly in Brussels. He painted mainly anecdotal genre scenes.

69
GAME KEEPER AND WOMAN AT
COTTAGE DOOR
Signed and dated lower right
H. Dillens B^{ues.} 1858
Canvas
$16 \times 13\frac{1}{4}$ (40·6 × 33·6)
Dixon Bequest
1050–1886

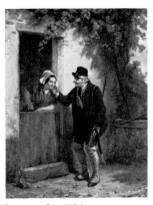

Prov. Joshua Dixon; bequeathed to Bethnal Green Museum in 1886.

C. H. DOLMUS (active c. 1870)
German School

70
PROFILE PORTRAIT OF A YOUNG WOMAN
Signed and dated lower right
C. H. Dolmus 1869
Canvas
$17\frac{7}{8} \times 14\frac{1}{2}$ (45·4 × 36·8)
Dixon Bequest
1082–1886

Prov. Joshua Dixon; bequeathed to Bethnal Green Museum in 1886.
Lit. Shaw Sparrow, 1892, p. 163, repr.

Friedrich DÜRCK (1809–84)
German (Munich) School

Born in Leipzig, where he was a pupil of Schnorr von Carolsfeld, he studied at the Munich Academy from 1824 to 1829. After a visit to Italy in 1836–37, he settled in Munich. His portraits were much sought after and he was called as portrait painter to the courts of Sweden (1849) and Austria (1854). In the latter part of his career he specialized in genre scenes with children.

71
THE VESPER BELL: THE YOUNG
REAPERS
Signed and dated lower right
F. Dürck 1848
Canvas
45¼ × 54 (114·9 × 137·2)
Townshend Bequest
1538–1869

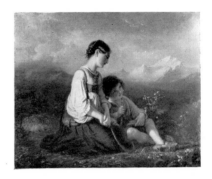

Prov. The Rev. C. H. Townshend; bequeathed to the Museum in 1868.

Léon Victor DUPRÉ (1816–79)
French School

Brother and pupil of Jules Dupré – a leading member of the Barbizon School – he exhibited landscapes at the Salon from 1839 to 1878.

72
COWS DRINKING
Signed and dated lower left
Léon Dupré 55
Panel
12¾ × 9½ (32·4 × 24)
Townshend Bequest
1616–1869

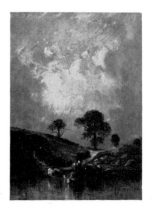

Prov. C. H. Townshend; bequeathed to the Museum in 1868.

DUTCH School, 19th century

73

ROCKY LANDSCAPE WITH FIGURES AND
MOUNTAINS

Signed lower right *J. S. K.*

Oak panel

$10\frac{1}{2} \times 14\frac{5}{8}$ (26·6 × 42)

560–1870

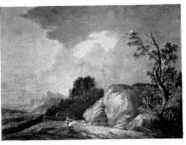

A label on the back inscribed in Parsons' handwriting: 'Jacob and S.
Ruysdael – companion – Bot. of Read Febr. 2nd 1857. The initials 'J.S.R.'
for Jacob and Solomon Ruysdael are at right hand corner.'

In fact the painting – and its companion, see 561–1870 (no. 74) – is
early 19th century, though in a traditional style and with 18th century
costumes. The initials are J.S.K. and appear to be genuine, but the
artist has not been identified.

Prov. Bought by John Parsons from Read, 2 Feb. 1857; bequeathed to the Museum
in 1870.

74

ROCKY LANDSCAPE WITH FIGURES AND
BUILDINGS

Signed lower right *J. S. K.*

Oak panel

$10\frac{5}{8} \times 14\frac{5}{8}$ (27 × 31)

561–1870

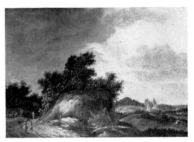

Companion piece to 560–1870 (no. 73).

Prov. John Parsons; bequeathed to the Museum in 1870.

Théophile Emmanuel DUVERGER (1821–after 1882)

French School

Born in Bordeaux, he exhibited genre scenes at the Paris Salon from 1846
to 1882, receiving medals in 1861, 1863 and 1865.

75

INTERIOR WITH TWO WOMEN
EXAMINING CLOTH

Signed lower right *DUVERGER*

Panel

$11\frac{5}{8} \times 9\frac{1}{8}$ (29·5 × 23·2)

Dixon Bequest

1074–1886

Prov. Joshua Dixon; bequeathed to Bethnal Green Museum in 1886.

Josephus Laurentius DYCKMANS (1811–88)
Belgian (Antwerp) School
Born at Lier in Holland, he settled in Antwerp in 1833 and soon achieved
a wide popularity through his carefully executed, smoothly finished, genre
scenes. He exhibited in London (1846–69), Paris (1855), and Vienna as well
as at Antwerp, and became well known as the 'Belgian Dou'.

76
GRANDMOTHER'S BIRTHDAY (LA ÉFTE
DE LA GRAND'MÈRE)
Signed and dated lower left
J. L. Dyckmans 1867
Oak panel
19 × 15⅝ (48·3 × 39·7)
1–1871

The grandmother was Mrs Sarah Heusch, the donor's mother. Painted
during the artist's residence in London.
Prov. Presumably painted for Frederick Heusch; bequeathed to the Museum in
1871.
Exh. Exposition historique, Brussels, 1880, catalogue: *L'art belge 1830–1880*, no.
318.
Lit. Thieme-Becker, x, 1914, p. 273.

Christian EZDORF (1801–51)
German (Munich) School
Born in Pössneck on the Oder, brother of the painter Friedrich Ezdorf, he
was a pupil at the Munich Academy. He specialized in painting mountain
scenery, visiting Norway and Sweden in 1821, Iceland in 1827, and Norway
in 1849 for this purpose. In 1834 he exhibited four works at the R. A. His
dramatic mountain views show the influence of Ruisdael and Everdingen.

77
THE TORRENT
Signed on wood centre foreground
C. EZDORF
Canvas
23⅝ × 31¾ (60 × 80·6)
Townshend Bequest
1556–1869

Prov. The Rev. C. H. Townshend; bequeathed to the Museum in 1868.

Ignace-Henri-Jean-Théodore FANTIN-LATOUR (1836–1904)
French School
Born at Grenoble, he was a pupil of his father, Théodore, who settled in
Paris in 1841, and then studied under Lecocq de Boisbaudran (1851–c.
1854), at the École des Beaux-Arts (1854) and in Courbet's Studio (1862).
From 1861 he exhibited regularly in the Salon. He visited England in
1859, 1861, 1864, and 1881 and exhibited at the R. A. 1862–1900. He
painted portraits and allegorical and mythological subjects as well as the
flower pieces upon which his reputation in England largely rested.
Lit. Mme Fantin-Latour, *Catalogue de l'oeuvre complet de Fantin-Latour*, 1911.

78
FLOWERS: TULIPS, AZALEAS, ROSES
ETC.
Signed and dated lower left
Fantin – 1864
Canvas
19¼ × 17⅜ (49 × 44)
Ionides Bequest
CAI.128

This and CAI.129 (no. 79) are good examples of Fantin's early flower pieces.
He was in England in 1864 and the Ionides family were among his most
important English patrons at this period.
Prov. Bought by Constantine Alexander Ionides from the artist; bequeathed to the
Museum in 1900.
Lit. Mme Fantin-Latour, *Oeuvre cat.*, 1911, p. 34, no. 244; F. Gibson, *The art of
Henri Fantin-Latour*, [1924], pp. 112, 226; Long, *Cat. Ionides Coll.*, 1925, p. 24, pl.
14; *Connoisseur*, lxxxviii, 1931, p. 118, repr.

79
FLOWERS: TULIPS, CAMELLIAS,
HYACINTHS ETC.
Signed and dated lower right
Fantin 1864
Canvas
19¼ × 17¼ (49 × 43·8)
Ionides Bequest
CAI.129

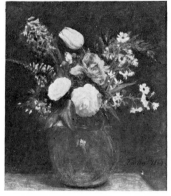

Prov. Bought by Constantine Alexander Ionides from the artist; bequeathed to the
Museum in 1900.
Lit. Mme Fantin-Latour, *Oeuvre cat.*, 1911, p. 34, no. 245; Gibson, *op. cit.*, pp. 112,
226; Long, *Cat. Ionides Coll.*, 1925, p. 24.

80
FLOWERS: IRIS, HYACINTHS ETC;
WITH CHERRIES AND ALMONDS ON
THE TABLE
Signed and dated lower right
Fantin. 71
Canvas
16¾ × 12¼ (42·5 × 31·1)
Ionides Bequest
CAI.130

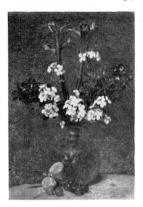

Prov. Bought by Constantine Alexander Ionides from the artist; bequeathed to the Museum in 1900.
Lit. Mme Fantin-Latour, *Oeuvre cat.*, 1911, p. 65, no. 535; Gibson, *op. cit.*, pp. 112, 226; Long, *Cat. Ionides Coll.*, 1925, p. 25; *Connoisseur*, lxxxix, 1932, p. 165, repr.

81
DAHLIAS
Signed and dated upper left
Fantin. 77
Canvas
10½ × 13¾ (26·7 × 34·8)
P.47–1917

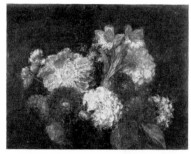

Prov. G. Tempelaere, the artist's friend and dealer (stencil on back of canvas: *Tableaux Modernes/G. Tempelaere/28, Rue Lafitte, 28/Paris*); Henry L. Florence; bequeathed to the Museum in 1917.

82
WHITE LILIES
Signed and dated upper right
Fantin. 77
Canvas
17 × 11⅞ (43 × 30)
S.Ex.61–1882

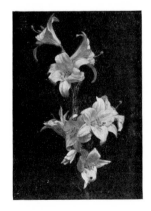

This and the following two paintings (nos. 83 & 84) belong to the relatively rare group of Fantin's flower pieces in which a single flower, depicted without vase or table, is silhouetted against a plain background. A painting

closely related to S.Ex.61–1882, *Branche de lis sans vase*, dated 1883, was sold at Sotheby's, 1 July 1964, lot 38, repr. (now coll. Mrs E. Hutton, Westbury, Long Island).

The Museum bought all three of these paintings from Mrs Ruth Edwards, widow of the painter Edwin Edwards, who had been a close friend of Fantin's and who, from 1871, acted as his agent in London. A portrait of Mr and Mrs Edwards by Fantin is in the Tate Gallery (no. 1952).

Prov. Bought from Mrs Edwin Edwards in 1882 as one of a series of 'schools examples', which were circulated to schools for use in art classes.
Exh. Fantin-Latour flower paintings, Marlborough Fine Art, 1962, no. 8, repr. p. 22.
Lit. Mme Fantin-Latour, *Oeuvre cat.*, 1911, no. 843.

83
NASTURTIUMS
Signed and dated upper left
Fantin – 80
Canvas
$24\frac{3}{4} \times 16\frac{3}{4}$ (62·8 × 42·5)
S.Ex.24–1884
See no. 82

Condition. Detached from cardboard secondary support, relined and cleaned in 1960.
Prov. Bought from Mrs Edwin Edwards in 1884 as one of a series of 'schools examples', which were circulated to schools for use in art classes.
Lit. Mme Fantin-Latour, *Oeuvre cat.*, 1911, p. 104, no. 1004.

84
CHERRIES
Signed and dated lower right
Fantin. 83
Canvas
$11\frac{7}{8} \times 11\frac{1}{4}$ (30 × 28·5)
S.Ex.4–1889
See no. 82

Condition. Cleaned in 1958.

Prov. Bought from Mrs Edwin Edwards in 1889 as one of a series of 'schools examples', which were circulated to schools for use in art classes.
Lit. Mme Fantin-Latour, *Oeuvre cat.*, 1911, p. 114, no. 1121.

FRENCH School, early 19th century

85
CATHERINE DE MÉDICIS WITH THE
HEAD OF COLIGNY
Sycamore (?) panel
$9\frac{7}{8} \times 8\frac{3}{8}$ (25 × 21·3)
Townshend Bequest
1381–1869

Gaspard de Coligny (1517–70), one of the leaders of the Protestants in France, was killed during the St Bartholomew night massacre, 24–5 August 1570, organized by Catherine de Médicis and the Guise family. Catherine is shown looking at Coligny's head, which is lying on the table before her, wrapped in a white cloth. The subject is unusual in French painting.

The original attribution was to Jan Mostaert (c. 1475–1555) (1893 *Catalogue*, p. 182), an artist who, as John Pope-Hennessy (1940) pointed out, died many years before the event represented in the picture. Pope-Hennessy attributed it to the early Delacroix. This attribution has not found general acceptance, though it is undoubtedly true that the picture should be given to a French painter of the Romantic period.

Condition. The panel is wedge-shaped and was presumably originally prepared for a different purpose.
Prov. The Rev. C. H. Townshend; bequeathed to the Museum in 1868.
Lit. J. Pope-Hennessy, 'An unpublished painting by Delacroix' in *Burl. Mag.*, lxxvii, 1940, p. 88, repr.

French School, c. 1830
86
A MAN IN A BLACK
FROCK COAT
Card
$15\frac{7}{8} \times 11\frac{3}{8}$ (40·4 × 29)
P.44–1962

Prov. Messrs. P. & D. Colnaghi; Claude D. Rotch, bequeathed to the Museum in 1962.

Johann Jakob FREY (1813–65)
Swiss School; worked in Rome
Born in Basel, where he was a pupil of his father, Samuel Frey (1785–1836), he spent some time in Paris and Munich before moving to Rome in 1835. He visited Naples, Sicily, Spain and, in 1842, Egypt, subsequently settling in Rome. A founder member of the German *Künstlerverein* there, he received commissions from German visitors, including Frederick William IV of Prussia. He painted mainly Italian landscapes and also Spanish and Egyptian subjects.

87
ITALIAN LANDSCAPE WITH PEASANTS
Signed and dated lower right
J. J. Frey Roma 1855
Canvas
$20\frac{5}{8} \times 26\frac{1}{4}$ (52·4 × 66·7)
Dixon Bequest
1058–1886

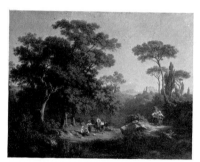

Prov. Joshua Dixon: bequeathed to Bethnal Green Museum in 1886.

Baldomero GALOFRE y Gimenez (1849–1902)
Spanish School
Born at Reus, Catalonia, he studied at Barcelona and then from 1870 to 1873 in Madrid. In 1873 he obtained the Rome Prize of the Madrid Academy and spent the following year in Rome and Naples. From 1886 until his death in 1902 he again lived in Barcelona. He exhibited at the R. A. in London (from 1882) and also in Munich, Vienna and Berlin as well as in Spain, and enjoyed considerable fame as a naturalistic painter of Spanish genre scenes and festivals.

88
A FAIR IN ANDALUSIA WITH HORSE
RACING
Signed lower right *B. GALOFRE*
Panel
13 × 19 (48·5 × 33)
P.53–1917

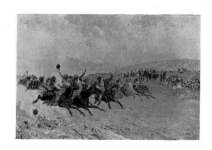

Singled out by Temple and in Thieme-Becker as one of this artist's best works.

Prov. Henry L. Florence before 1901; bequeathed to the Museum in 1917.
Exh. Works of Spanish painters, Corporation of London Art Gallery, Guildhall, 1901, no. 167.
Lit. A. G. Temple, *Modern Spanish painting*, 1908, p. 96, repr. p. 102; Thieme-Becker, xiii, 1920, p. 132 f.

Enrico GAMBA (1831–83)
Italian School
Born in Turin, he studied at the Academy there and, in 1850–52, at the Städelsches Kunstinstitut, Frankfurt, where he was influenced by the Nazarenes. In 1852–54 he visited Venice and Rome, subsequently settling in Turin, where he became professor at the Academy, and where he was commissioned to paint decorative scenes for the town hall.

89
DON QUIXOTE AT THE INN
Signed and dated lower left *E. Gamba*
(initials in monogram) *1876*
Canvas
$28\frac{1}{2} \times 22\frac{1}{2}$ (72·4 × 57·2)
1846–1900

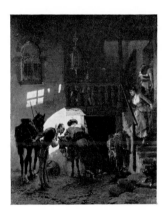

Prov. H. S. Ashbee; bequeathed to the Museum in 1900.

Friedrich GAUERMANN (1807–62)
Austrian School
Born at Miesenbach not far from Vienna, the son of the painter Jakob Gauermann, he was a pupil at the Vienna Academy from 1824 to 1827. His earliest works earned him the description of realist, but from about 1830 he concentrated more on Romantic alpine scenery and rapacious wild animals. A member of the Vienna Academy from 1836, his great popularity with both the Austrian aristocracy and foreign patrons is attested by the high prices listed in his account book. His later work tended to be duller and repetitive.
Lit. R. Feuchtmüller, *Friedrich Gauermann 1807–62*, Vienna, 1962.

90
WOLVES ATTACKING A STAG AND A
DEER
Signed and dated lower right
F. Gauermann 1834
Canvas
27 × 22 (68·6 × 56)
Sheepshanks Gift
FA.77

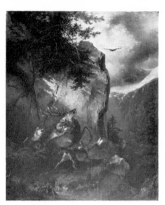

According to Gauermann's account book, this picture was painted in
February 1834 and paid for by F. W. Fink of the Albertina, who was the
intermediary between Sheepshanks and the artist. It was etched by E. Webb
and B. P. Gibbon in 1837. Feuchtmüller lists two preparatory drawings:
(1) pencil and wash, 32·6 × 27 cm., inscribed *ausgeführt für Fink kam nach
London 1834 an Schipings* [Sheepshanks], Kupferstichkabinett, Akademie
der Bildenden Künste, Vienna, no. 7039: (2) pencil, 17 ×15·7 cm.,
Kupferstichkabinett, Dresden.

Condition. Slight flaking at lower edge.
Prov. Bought by John Sheepshanks from the artist through F. W. Fink of the
Albertina, Vienna in 1834 (100 florins); given to the Museum in 1857.
Exh. Vienna Academy, 1834.
Lit. Feuchtmüller, *op. cit.*, pp. 49, 152, 174, no. 117.

91
WILD BOARS AND WOLF
Signed and dated lower right
F. Gauermann 1835
Canvas
29 × 33 (73·7 × 83·8)
Sheepshanks Gift
FA.78

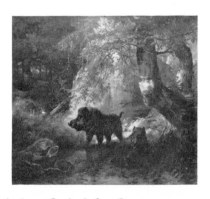

The price paid for this picture was high (500 florins) for Gauermann at
this period and it remains among his most impressive works. According to
his account book, it was painted in June 1835 and sent to England in
December. Feuchtmüller lists one preparatory drawing: pen and wash
27·8 × 33·5 cm., inscribed *In London. Ausgeführt für H. Schipings in
London 1835*, Kupferstichkabinett, Akademie der Bildenden Künste,
Vienna, no. 7049.

In stressing Gauermann's high reputation among his contemporaries, it
is of interest to note that he was the only foreign artist represented in
Sheepshanks' gift to the Museum and when the Prince Consort visited the

newly opened paintings gallery in 19 June 1857 he singled out these two
pictures: 'In looking through the South Gallery, he noticed two pictures
by Gauermann. He seemed to know him and his works. 'He was' said the
Prince, 'Court painter of animals and he also painted the late Emperor of
Austria and all his family . . . ' (F. M. Redgrave, *Richard Redgrave, A
memoir*, 1891, p. 174. There is no supporting evidence for the statement
that he painted the Austrian Emperor; perhaps this was a royal joke).

Prov. Bought by John Sheepshanks in 1835 direct from the artist (500 florins);
given to the Museum in 1857.
Lit. Waagen, *Treasures of art in Great Britain*, ii, 1854, p. 306; Feuchtmüller, *op.
cit.*, p. 176, no. 128, pl. 52.

Jean-Philippe GEORGE (1818–88)
Swiss (Geneva) School
Born in Geneva, he studied in Nantes and, from 1842, in Paris under
Calame. He painted mainly Alpine scenes and exhibited in Geneva from
1845 to 1886.

Ascribed to Jean-Philippe GEORGE

92
St Joire, Savoy
Signed lower centre with a monogram
HPG
Mill board
14 × 11⅞ (35·5 × 30)
Townshend Bequest
1603–1869

The monogram was identified by Nagler, *Die Monogrammisten*, iii, 1863,
no. 1370, as that of 'Henri Philippe Georges' of Geneva, though he added
that he had only seen it on one example of the artist's work, a lithograph of
Cape Miseno published in *Esquisses d'atelier. Publication du Cercle des
Artistes*, i, Geneva, 1853.

1603–1869 entered the Museum as by H. P. Georges and was subse-
quently catalogued as such (1893 *Catalogue*, p. 163). Brun's *Schweizerisches
Künstlerlexikon*, i, 1905, p. 563, described this artist as Jean-Philippe
George 'Quelquefois appelé Henri-Philippe'; the entry in Thieme-Becker,
xiii, 1920, p. 425 is even firmer: 'Jean Philippe, nicht Henri Philippe'.

In spite of this difficulty over the name, it would seem likely that 1603–
1869 is by this artist, were it not for the fact that it differs considerably
from his paintings in the Geneva Museum and elsewhere. It is painted in
an early 19th century style and may be dated c. 1820–40; Jean-Philippe
George was essentially a naturalistic landscape painter, influenced by
Calame, whose pupil he was from 1842. If this is by him, it must be a very

early work painted when he was twenty or younger, before his mature style was formed.

Prov. The Rev. C. H. Townshend; bequeathed to the Museum in 1868.

Luigi di GIOVANNI (1856–after 1900)
Sicilian School
Born in Palermo he was a pupil of Domenico Morelli in Naples (1863–72) and then returned to Palermo in 1882. He exhibited history and genre subjects and portraits in the 1880s and '90s (Palermo; Turin, 1898; Munich, 1888, 1892).

Ascribed to Luigi di GIOVANNI

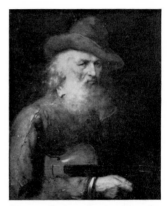

93
AN ITALIAN FIDDLER
Signed lower right *Giovanni*
Canvas
30½ × 24⅜ (77·5 × 62)
Dixon Bequest
1079–1886

Acquired simply as by 'Giovanni', after the form of the signature, the painter may reasonably be identified with the Sicilian painter Luigi di Giovanni.

Prov. Joshua Dixon; bequeathed to Bethnal Green Museum in 1886.

Josef de GROOT (1828–99)
Dutch School
Born in Sneek (Friesland), he was a pupil at the Amsterdam Academy. He painted mainly genre scenes.

94
THE BILLET DOUX
Signed lower left *J. de Groot*
Canvas
22¼ × 18¼ (56·5 × 46·3)
502–1870

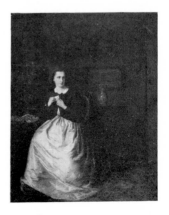

Prov. Sold at Christie's, 18 April 1867, lot 6, for £8 to J. M. Parsons; bequeathed to the Museum in 1870.

Cecil van HAANEN (1844–c. 1885)
Dutch School
Born in Vienna, he was a pupil of his father, Remigius, and also of van Lerius in Antwerp and at the Academy in Karlsruhe in 1863–64. In 1873 he went to Venice and subsequently lived in England and Vienna. He painted mainly Venetian genre scenes in the manner of Passini, and his work is similar to that of English painters of Venetian subjects, like Luke Fildes and Henry Woods.

95
HEAD OF A YOUNG GIRL
Panel
$7\frac{1}{4} \times 5\frac{1}{4}$ (18·3 × 13·4)
P.26–1917

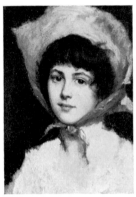

Prov. Henry L. Florence; bequeathed to the Museum in 1917.

Samuel Baruch HALLE (1824–89)
German School; worked in England and France
Born in Frankfurt, he had moved to London by 1847, when he first exhibited at the R. A. He continued to exhibit genre scenes at the R. A. and elsewhere in London until 1868. Subsequently he moved to Paris, where he exhibited at the Salon from 1878 to 1882, and took up French nationality.

96
'GOOD MORNING MAMMA!': A
MOTHER AND CHILD CARESSING
Signed and dated lower left
S. B. Halle 18(59 ?)
Canvas
33 × $38\frac{3}{8}$ (83·8 × 97·5)
Dixon Bequest
1046–1886

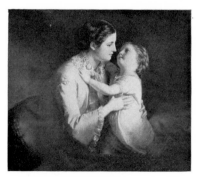

Prov. Joshua Dixon; bequeathed to Bethnal Green Museum in 1886.
Exh. Probably to be identified with *Mother's Pet*, exhibited at the R. A. in 1860, no. 580.

Karl HEFFNER (1849–after 1923)
German School
Born in Würzburg, he studied music and then painting in Munich. He travelled in England from the 1870s, working for his agent, the dealer Henry Wallis. In 1883 he visited Italy and then settled in Rome; he returned to Germany in 1894 to live in Dresden and ultimately in Berlin. A successful painter, he exhibited in Vienna, Munich, Berlin, London (R. A. 1880–81) and Paris. He specialized in twilight landscapes.

97
EVENING ON THE ISAR
Signed and dated lower right
K Heffner München 74
Canvas
$17\frac{1}{4} \times 32\frac{3}{4}$ (43·8 × 84·2)
864–1894

Prov. John Hill, of Streatham; bequeathed to the Museum in 1894.

98
LANDSCAPE, EVENING
Signed and dated lower left
K HEFFNER München 1875
Canvas
$30\frac{3}{4} \times 44\frac{1}{4}$ (78 × 112·4)
863–1894

Prov. This and the following paintings by Heffner were probably sold by Henry Wallis, who was Heffner's agent in London; John Hill of Streatham; bequeathed to the Museum in 1894.

99
RHENISH LOWLANDS
Signed lower left *K. Heffner München*
Canvas
$12\frac{1}{2} \times 38\frac{1}{4}$ (31·75 × 97·2)
865–1894
Not reproduced
Prov. John Hill, of Streatham; bequeathed to the Museum in 1894.

867A 867B

100
SIX SKETCHES IN ITALY (NATURSTUDIEN
VON ITALIEN)
Inscribed with titles on labels on
back and dated 1880
Panel
Each $4\frac{3}{4} \times 8\frac{1}{4}$ (12 × 21)
867–1894

867D 867E

867–94: Sailing boats at Chioggia, near Venice. Signed lower left *K. Heffner;* dated on back *6 Avril 1880*

867A–94: Distant view of Venice. Signed lower left *K. Heffner;* dated on back *1 Avril 1880*

867B–94: La Spezia. Signed and dated lower left *La Spezia 20 Mars 1880 K. Heffner*

867C–94: Genoa. Signed lower left *K. Heffner;* dated on back *15 Mars 1880*

867D–94: Chiavari, near Genoa. Signed lower left *K. Heffner;* dated on back *18 Mars 1880*

867E–94: Florence, Boboli Gardens and Cathedral. Signed lower right *K. Heffner;* dated on back *25 Mars 1880*

Prov. John Hill, of Streatham; bequeathed to the Museum in 1894.

101
Six sketches in Switzerland
(Naturstudien aus der Schweiz)
Inscribed with titles on labels on back
Panel
Each $4\frac{3}{4} \times 8\frac{1}{4}$ (12 × 21)
866–1894

866A 866B

866D 866E

866–94: Chamonix and Mont Blanc
866A–94: The Castle of Chillon on Lake Geneva
866B–94: Grindelwald and the Wetterhorn
866C–94: Fluelen, on the Lake of Lucerne
866D–94: Lauterbrunnen and the Staubbach Falls
866E–94: The Matterhorn

Prov. John Hill, of Streatham; bequeathed to the Museum in 1894.

Olof HERMELIN (1827–1913)
Swedish School
A pupil of the Stockholm Academy, he later studied in Paris (1870, '73, '75). He painted Swedish landscapes, which were exhibited regularly in Sweden and in Germany.

102
A Swedish lake scene
Signed and dated lower right
O. Hermelin 1873
Canvas
15 × $21\frac{3}{4}$ (38 × 55·2)
59–1908

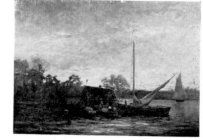

Prov. Mrs Elizabeth South; given to the Museum in 1908.

5

Eduard HILDEBRANDT (1818–69)
German (Berlin) School
Born in Danzig, he studied art in Berlin and settled there in 1843 after a
brief period as Isabey's pupil in Paris (1842–43). He was patronized by
Frederick William IV of Prussia, who sent him on numerous extensive
journeys (1843–45, Brazil, U.S.A.; 1847, England; 1851 Italy and the
Near East; 1862–64, journey round the world), which he recorded in
several hundred water-colours.

103
RAINY WEATHER: HORSES IN A STREAM
Signed and dated lower right
E. Hildebrandt 1848
Canvas
$15\frac{1}{2} \times 22\frac{3}{4}$ (39·4 × 57·8)
Townshend Bequest
1539–1869

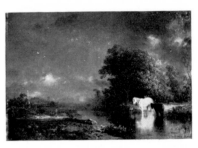

Prov. Acquired by the Rev. C. H. Townshend before 1854–56, when it was seen in
his dining room by Waagen; bequeathed to the Museum in 1868.
Lit. Waagen, *Supplement*, 1857, p. 178.

Charles HOGUET (1821–70)
German (Berlin) School
Born in Berlin of French parents, he began his studies there and completed
them as a pupil of Eugène Isabey in Paris in 1839–40. After various
journeys to England, Holland, Belgium and the Normandy coast, he
he returned to Germany and settled in Berlin. He was an immensely
productive painter, specializing in still life and land- and sea-scapes.

104
THE WINDMILL
Signed lower right *C. hoguet*
Panel
$16\frac{7}{8} \times 23\frac{3}{4}$ (42·9 × 60·3)
Townshend Bequest
1551–1869

Waagen found that 'this is superior to many pictures by this Berlin
painter in softness and transparency of colouring and excellence of keeping.'
Prov. Acquired by the Rev. C. H. Townshend before 1854–56, when it was seen in
his dining room by Waagen; bequeathed to the Museum in 1868.
Lit. Waagen, *Supplement*, 1857, p. 177.

105
A BRIDGE
Signed lower left *C. hoguet*
Panel
6 × 9¾ (15·2 × 24·8)
Townshend Bequest
1561–1869

Prov. The Rev. C. H. Townshend; bequeathed to the Museum in 1868.

106
BOATS BY THE BEACH
Signed lower right *C. hoguet*
Panel
5½ × 13⅞ (14 × 35·2)
Townshend Bequest
1572–1869

Prov. The Rev. C. H. Townshend; bequeathed to the Museum in 1868.

107
BOAT ON SHORE
Signature lower left no longer legible
Panel
4½ × 5¾ (11·4 × 14·6)
Townshend Bequest
1574–1869
Not reproduced
Prov. The Rev. C. H. Townshend; bequeathed to the Museum in 1868.

Joseph HORNUNG (1792–1870)
Swiss (Geneva) School
Born in Geneva, where he lived throughout his life, he painted landscapes
and genre scenes and, increasingly after 1829, history pieces.

108
THE DAM
Signed and dated lower right
J. Hornung 1850
Panel
18¼ × 15 (46·4 × 38)
Townshend Bequest
1614–1869

Prov. The Rev. C. H. Townshend; bequeathed to the Museum in 1868.

109
THE VILLAGE TURNER
Signed lower right *J. Hornung*
Panel
$11\frac{1}{8} \times 8\frac{1}{2}$ (28 × 21·6)
Townshend Bequest
1596–1869

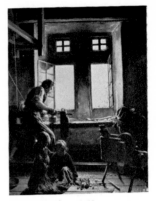

Prov. The Rev. C. H. Townshend; bequeathed to the Museum in 1868.

Hubertus van HOVE (1814–65)
Dutch School
Born at The Hague, he was the son and pupil of Bartholomeus Johannes van Hove. He lived at The Hague until 1854, when he moved to Antwerp. He began his career as a landscape painter, but then turned to interiors in the costume and manner of the Dutch 17th century, in particular reminiscent of Pieter de Hooch (1629 ?–after 1684).

110
THE LISTENING SERVANT
Signed lower right *H V Hove*
[the HVH in monogram] *53* (?)
Panel
$30 \times 39\frac{3}{4}$ (76·2 × 101)
Townshend Bequest
1540–1869

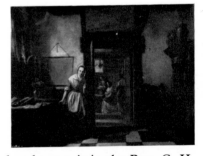

Waagen aptly described this painting when he saw it in the Rev. C. H. Townshend's dining room in 1854–56: 'Like most specimens of this favourite Dutch painter, this picture is skilfully treated in the taste of Peter de Hooghe. The three figures, however, are insufficient to give interest to the large size of the work.' This particular subject was more probably derived from Nicolaes Maes (1634–93), who painted it several times (W. R. Valentiner, *Nicolaes Maes*, 1924, pls. 38–42; cf. esp. pl. 40, Wellington Museum, Apsley House).

Prov. Bought by the Rev. C. H. Townshend before 1854–56, when it was seen in his collection by Waagen; bequeathed to the Museum in 1868.
Lit. Waagen, *Supplement*, 1857, p. 177.

(Jean) Charles Ferdinand HUMBERT (1813–81)
Swiss School
Born in Geneva, where he was a pupil of Hornung and of Calame, he also

studied in Paris under Ingres. From 1835 he exhibited regularly in
Geneva. He painted mainly animal subjects.

111
HORSES AT PLOUGH
Signed lower left *Humbert 1850*
Panel
15½ × 21¾ (39·4 × 55·2)
Townshend Bequest
1605–1869

Prov. The Rev. C. H. Townshend; bequeathed to the Museum in 1868.

Jean Auguste Dominique INGRES (1780–1867)
French School
Born at Montauban, he studied at Toulouse and then in Paris under
David. He won the Prix de Rome in 1801, but was unable to proceed to
Rome until 1806. He then lived in Rome until 1820, and in Florence
1820–24. On his return to Paris he received the Cross of the Legion of
Honour from Charles X and was elected to the Académie des Beaux-Arts.
In 1835–41 he was again in Rome, as director of the French school. He was
made a senator in 1862. Ingres painted portraits and historical, mytho-
logical, allegorical and religious subjects; he excelled as a draughtsman.

112
A SLEEPING ODALISQUE
Signed lower left *J. Ingres*
Canvas
11¾ × 18¾ (29·8 × 47·6)
Ionides Bequest
CAI.57

Delaborde (1870) followed by Long (1925) considered this to be a study for
the *Odalisque à l'Esclave* of 1839 (Fogg Art Museum, Cambridge, Mass.;
Wildenstein, no. 228, fig. 149), but Lapauze (1911),Wildenstein (1956) and
Rosenblum (1967) argued that it was more probably related to the *Dormeuse
de Naples,* painted for Murat, King of Naples, in 1808. This painting is
lost, but there are various drawings of sleeping odalisques in the Musée
Ingres at Montaubon (Lapauze, p. 102; *La Revue de l'Art français,* iv,
1921, p. 193, repr.), which are thought to be studies for it. Like these
drawings, CAI.57 shows a naked, sleeping woman, whereas the odalisque in
L'Odalisque à l'Esclave has her legs draped and is clearly shown as looking

at the slave playing the guitar. There are two very similar paintings, one in a private collection, Paris (Wildenstein, no. 56, fig. 37; 8⅝ × 14⅛ in.); the whereabouts of the other is unknown (Wildenstein, no. 57, fig. 36). These differ in the position of the woman's right arm and right leg but are otherwise closely related to CAI.57. There is an engraving by Auguste François Alès (1797–1878) after the Ionides painting which is reproduced in *L'Artiste*, 14 December 1856, p. 16.

Prov. Baron Jules de Hauff, Brussels (not in the Hauff sales, Brussels, 14 April 1875, or 13 March 1877); before 1884, Constantine Alexander Ionides; bequeathed to the Museum in 1900.

Exh. French and Dutch Loan Collection, Edinburgh International Exhibition, 1889, no. 1173 (no. 68 of *Mem. cat.*); *French and Dutch Romanticists*, Dowdeswell Galleries, 1889, no. 192; Winter Exhibition, R.A., 1896, no. 87.

Lit. Monkhouse, 1884, p. 39; Sir C. Holmes in *Burl. Mag.*, v, 1904, p. 531, repr.; H. Delaborde, *Ingres*, 1870, p. 239, no.79; J. Momméja,'Le "Bain Turc" d'Ingres' in *Gazette des Beaux-Arts*, xxxvi (2), 1906, p. 186; H. Lapauze, *Ingres*, 1911, p. 102; Long, *Cat. Ionides Coll.*, 1925, p. 28, pl. 18; G. Wildenstein, *Ingres*, 2nd ed.,1956, no. 55, fig. 35; R. Rosenblum, *Ingres*, 1967, p. 142, fig. 125.

113
HENRI IV, THE DAUPHIN AND THE
SPANISH AMBASSADOR: A SKETCH
Signed lower left *Ingres*
Canvas
19⅞ × 24½ (50·5 × 62·3)
Ionides Bequest
CAI.58

The King, being discovered playing as a horse for his children, asked the ambassador if he were a father, and on receiving an affirmative reply, observed quietly, 'Then I shall finish my round.'

This is one of four recorded versions: (1) Whereabouts unknown; painted for the Comte de Blacas, French Ambassador in Rome, and dated 1817 (Delaborde, no. 63; Wildenstein, no. 113, fig. 61); (2) private collection, Paris; Ingres sale, 27 April 1867, no. 9 (Delaborde, no. 66; Wildenstein, no. 115, fig. 62); (3) Whereabouts unknown, formerly Baron Alphonse de Rothschild collection; a replica of (1), dated 1828 (Delaborde, no. 65; Wildenstein, no. 204).

These differ considerably from CAI.58. They show Marie de Médicis seated in the middle of the composition and include four children instead of only one. CAI.58 is clearly a sketch. Perspective guidelines are visible on the floor and there are indications that the artist changed the composition in several places. A shadowy figure on the extreme left is partially visible behind the door, and the door itself appears to have been moved from its original position.

It differs too greatly from the finished version, Wildenstein, no. 113, to

be called a sketch for it, but Delaborde's description of it as a 'première pensée' would seem acceptable. As the finished version is dated 1817, a date c. 1816–17 may be proposed for CAI.58. The drawings in the Musée Ingres at Montauban (esp. nos. 867–1402, 867–1409) relate more closely to Wildenstein no. 113 than to CAI.58. It was engraved by Adrian Nargeot (*L'Artiste*, 1876).

There are two paintings of the same subject by Bonington (1802–28) in the Wallace Collection (no. 351, oil on canvas; no. 733 water-colour). The subject was also painted by Pierre Henri Revoil (1776–1842) (L. Rosenthal, *La peinture romantique*, 1900, p. 75).

Prov. Given by Ingres to Dominique Papety, pensionnaire of the Académie de France in Rome (according to Wildenstein); M. Delavey berette, Duc de Morny; before 1876, M. Meyer; before 1884, Constantine Alexander Ionides; bequeathed to the Museum in 1900.
Exh. French and Dutch Romanticists, Dowdeswell Galleries, 1889, no. 193.
Lit. H. Delaborde, *Ingres*, Paris, 1870, p. 230, no. 64; R. de la Ferté, 'Les petits tableaux de Ingres' in *L'Artiste*, 1876, pl. i, p. 51 f., repr.; C. Monkhouse, 1884, p. 39; Anon., 'Additions to the National Collections' in *Athenaeum*, July 1904, p. 119; H. Lapauze, *Ingres, sa vie et son oeuvre*, 1911, p. 189; G. Wildenstein, *Ingres*, 2nd ed., London, 1956, no. 114, fig. 63.

ITALIAN School, c. 1890

114
Two lovers in Renaissance costume on the terrace in the garden of the Villa D'Este, Tivoli
Canvas
18¾ × 14¾ (48 × 38)
321–1899

Prov. Mme Postma; given to the Museum in 1899.

Jacob Albert Michael JACOBS (1812–79)
Belgian School
Born at Antwerp, he studied at the Academy there and exhibited at the Antwerp Salon from 1833. He was in Holland in 1837 and travelled in Egypt, Greece and Russia in the following year. In 1845 he was living in London, where he exhibited at the R. A. (Graves, *Royal Academy*, iv, p. 32,

confused with John Jacobs). He became a member of the Brussels Academy in 1875. He was one of the best known sea- and landscape painters of his time.

115
HOVE DOWN TO CAREEN
Oil sketch on card
8 × 12 (20·5 × 30·5)
Townshend Bequest
1631–1869

Prov. The Rev. C. H. Townshend; bequeathed to the Museum in 1868.

116
FISHING BOAT ENTERING HARBOUR
Oil sketch on panel
Painted surface: 9 × 12 (23 × 30·5)
Size of panel: 18 × 22¾ (46 × 58)
Townshend Bequest
1632–1869

Prov. The Rev. C. H. Townshend; bequeathed to the Museum in 1868.

Godefroy JADIN (1805–82)
French School
Born in Paris, he was a pupil of L. Hersent and A. de Pujol and exhibited at the Salon from 1831. He specialized in painting hunting scenes and animal subjects and was particularly popular for his studies of dogs. Napoleon III dubbed him 'Peintre de la vénerie impériale'.

117
TWO GREYHOUNDS
Signed and dated lower right
G. JADIN. 1850
Canvas
45 × 57½ (114 × 146)
86–1880
Not reproduced

Prov. F. R. Bryan; given to the Museum in 1880.
Lit. Thieme-Becker, xviii, 1925, p. 321 (listed as *Étude de lévriers*).

Nicaise De KEYSER (1813–87)
Belgian School
Born near Antwerp, where he subsequently studied and lived, he achieved considerable success with a series of battle scenes in the early 1840s. He also painted genre scenes in the tradition of 17th century Flemish art, and was considered one of the leading Belgian painters of his time.

118
THE PHILOSOPHER
Signed lower left *DK*
Canvas
20½ × 16½ (52 × 42)
Townshend Bequest
1557–1869

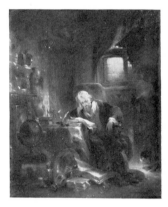

Prov. Acquired by the Rev. C. H. Townshend before 1854–56, when it was seen by Waagen in his dining room; bequeathed to the Museum in 1868.
Lit. Waagen, *Supplement*, 1857, p. 178.

Johann Baptist KIRNER (1806–66)
German School
Born at Furtwangen (Baden), he studied at Augsburg (1822–24) and Munich (1824–29). In 1832–37 he was in Rome with Winterhalter and, thereafter, settled in Munich. In 1840 he was appointed court painter to the Grand Duke of Baden, and spent some time in Karlsruhe painting portraits of the ducal family, but the greater part of his work consists of genre paintings.

119
PLAYING AT SOLDIERS: THE ROMAN
REVOLUTION, 1848
Signed and dated lower right
J. Kirner 1848
Canvas
17 × 21¾ (43·2 × 55·2)
Townshend Bequest
1550–1869

The children's banner is inscribed *Eviva Italia/Eviva Pio nono/e la Constitutione.*

Prov. Acquired by the Rev. C. H. Townshend before 1854–56, when it was seen in his dining room by Waagen; bequeathed to the Museum in 1868.
Lit. Waagen, *Supplement*, 1857, p. 177.

J. B. KLOMBECK (active c. 1845–after 1872)
Dutch School
Born in Cleve, he was a pupil of B. C. Koekkoek. He painted mainly landscapes, which he exhibited at the Academies in Dresden (1851) and Berlin (1856 and '66).

120
TREES IN A STORM
Signed lower right *JB. Klombeck ft.*
1845
Panel
15 × 18¼ (38 × 46·4)
Townshend Bequest
1568–1869

Prov. The Rev. C. H. Townshend; bequeathed to the Museum in 1868.

Julius KOECKERT (1827–1918)
German (Munich) School
Born in Leipzig, he studied in Coblenz and in Cologne before moving to Prague in 1843. He was in Bavaria in 1848 and settled in Munich in 1850. He painted mainly Alpine scenes, which were widely popular in his lifetime.

121
MIDNIGHT FIRES ON THE ALPS
Signed lower left
Julius Köckert München
Canvas
43 × 63 (109·2 × 160)
Dixon Bequest
1067–1886

Prov. Joshua Dixon; bequeathed to Bethnal Green Museum in 1886.

Hermann KOEKKOEK (1815–82)
Dutch School
The son of the painter Johann Herman Koekkoek, he lived mainly in

Amsterdam and became a member of the Amsterdam Academy. He painted seascapes in the manner of Backhuysen.

122
SEA PIECE: A THREATENING SKY
Signed and dated lower right
H. Koeck.Koeck. 1844
Panel
16¾ × 22½ (42·5 × 57·2)
Townshend Bequest
1558–1869

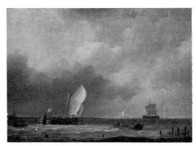

Prov. The Rev. C. H. Townshend; bequeathed to the Museum in 1868.

123
SEA PIECE: CALM WATERS
Signed lower left *H. Koekkoek fᵗ*
Panel
9⅜ × 13½ (23·3 × 34·3)
Townshend Bequest
1565–1869

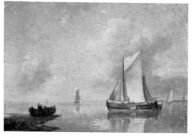

Prov. The Rev. C. H. Townshend; bequeathed to the Museum in 1868.

Wilhelm KOLLER (1829–84)
Born in Vienna, where he was a pupil of Waldmüller, he also studied in Düsseldorf, Paris and Antwerp. In 1859 he settled in Brussels, ten years later he moved to Paris. He was a well known painter of costume pieces.

124
GOING TO CHURCH: A 16TH CENTURY
COSTUME PIECE
Signed lower left *G. Koller 1857*
Panel
32 × 51⅞ (86·4 × 132)
Dixon Bequest
1048–1886

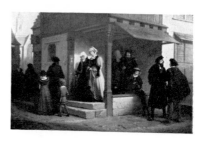

Prov. Joshua Dixon; bequeathed to Bethnal Green Museum in 1886.

Everhardus KOSTER (1817–92)
Dutch School
Born at The Hague, he studied at The Hague and in Frankfurt. In 1848 he settled in Amsterdam and achieved considerable success as a painter of

river views and seascapes. He visited England in 1856 and 1859. The loss of his right eye in 1859 made it more difficult for him to paint and he subsequently worked as a curator in the Museum of Modern Art, Haarlem, of which he became director in 1876.

125
THE PRINCE OF ORANGE, AFTERWARDS
KING WILLIAM III, EMBARKING AT
HELLEVOETSLUIS FOR ENGLAND IN
1688
Signed lower left *E. Koster. ft.*
Canvas
58 × 157½ (147·3 × 400)
376–1876

Prov. Baron de Ferrières; given to the Museum in 1876.
Exh. British Empire Exhibition, Wembley, 1924 and 1925.

126
WILLIAM III REVIEWING THE DUTCH
FLEET IN 1691
Signed lower left *E. Koster ft.*
Canvas
58 × 157½ (147·3 × 400)
377–1876

Prov. Baron de Ferrières; given to the Museum in 1876.
Exh. British Empire Exhibition, Wembley, 1924 and 1925.

Gotthardt KUEHL (1850–1915)
German (Dresden) School
Born in Lübeck, he was a student at the Academies of Dresden and Munich. From 1878 until 1889 he lived in Paris, where he came under the influence of Manet and Bastien Lepage; on trips to Holland he studied the Dutch 17th century painters, especially Vermeer and de Hooch. In 1889 he settled in Dresden, where he became professor at the Academy in 1895.

127
THE DISPUTE
Signed and dated lower right
G.Kuehl. Paris. 81
Panel
9¼ × 13 (23·5 × 33)
P.52–1917

Prov. Thomas M'Lean, art dealer, 7 Haymarket (label on back); Henry L. Florence; bequeathed to the Museum in 1917.

Adrien KUNKLER (1829–66)
Swiss School
Born in Morges, he was a pupil of J. L. Lugardon and Ch. Humbert in
Geneva. He travelled extensively in Savoy in 1854, in Spain in 1855, 1856
and 1857, and was a keen observer of local customs.

128
AN OFFER OF MARRIAGE
Signed lower right *A.Kunkler 1855*
Canvas
15 × 18 (38·1 × 45·7)
Townshend Bequest
1609–1869

The scene is set in Savoy, where Kunkler stayed in 1854.
Prov. The Rev. C. H. Townshend; bequeathed to the Museum in 1868.

Carl Joseph KUWASSEG (1802–77)
Austrian School
Born in Trieste, he was a student at the drawing academy in Graz from
where he moved to Vienna. In 1830 he was in Paris and subsequently
accompanied Sir Robert Schomburgk on his travels in Southern Europe
and America. He became a naturalized French subject in 1870.

129
A VIEW IN THE TYROL
Signed and dated lower left
C. Kuwasseg 1857
Canvas
44 × 57 (112 × 145)
431–1895
Not reproduced
Prov. Messrs Galignani, Paris; given to Charles Dod; bequeathed to the Museum
in 1895.

Pierre LACAZE (1816–86)
Swiss School
A genre and landscape painter who worked in Freiburg and Lausanne. In
1840–45 he was a pupil of Ary Scheffer in Paris.

130
THE YOUNG STUDENT
Signed lower right *Lacaze*
Millboard
$12\frac{1}{4} \times 9\frac{5}{8}$ ($31 \times 24\cdot4$)
Townshend Bequest
1615–1869

The date appears to be c. 1840–50.

Prov. The Rev. C. H. Townshend; bequeathed to the Museum in 1868.

Prosper LAFAYE (1806–83)
French School

Prosper Lafaye, a cousin of Gavarni, was born at Mont-Saint-Sulpice (Yonne). He lived in Paris from the age of thirteen and became a pupil of Auguste Couder. He painted some battle scenes for Louis Philippe's Musée Historique at Versailles, but his most typical paintings are of interiors, characterized by the interplay of strong light and shade. He exhibited at the Salon from 1833, but lack of success in his later years led him to specialize in the painting and restoration of stained glass windows.

Lit. J. Wilhelm, 'Deux peintures par Prosper Lafaye' in *Bulletin du Musée Carnavalet*, 8, no. 2, 1955, pp. 12–5; *Exposition Gavarni et Prosper Lafaye*, Musée des Beaux-Arts, Auxerre, 1961.

131
QUEEN VICTORIA, PRINCE ALBERT
AND THREE OF THEIR CHILDREN AT THE
INDIAN PAVILION OF THE GREAT
EXHIBITION OF 1851
Canvas
$29\frac{3}{4} \times 44\frac{1}{4}$ ($75\cdot5 \times 112\cdot5$)
P.9–1966

The painting was begun in 1851, when the interior of the pavilion was painted. Most of the figures, including those of Queen Victoria, Prince Albert and the children (left of centre), and of Lafaye's grand-daughter Yvonne (one of the donors of the picture) in the left foreground, were added in 1881. A note to this effect appears in the artist's diary under 12 August 1881:

'Terminé à peu près le tableau commencé il y a au moins 30 ans représentant l'intérieur de l'exposition des Indes. Introduit la reine d'Angleterre

et des figures de toutes sortes, entre autres la petite Yvonne et sa mère et des personnages du Mont [St Sulpice], etc.'

The Museum also has an almost full-size water-colour sketch (P.56–1968; $21\frac{3}{8} \times 41$ in., dated 1851–69), in which the pavilion is identical but the disposition of the figures – apparently added in 1869 – differs. There are pencil drawings of the individual commissioners in the Dept. of Prints & Drawings (E.130/70–1968) and another version in oil in the Musée des Arts Décoratifs, Paris.

Condition. Flaking surface laid down and canvas relined in 1966.
Prov. Direct descent in the artist's family; given to the Museum in 1966 by Dr Germaine Montreuil-Straus and Mademoiselle Yvonne Montreuil in memory of their grandfather, Prosper Lafaye.
Lit. For the preparatory sketches see: V. & A. Museum, *Dept. of Prints & Drawings and Dept. of Paintings: Accessions 1968*, pp. 138–45, 161.

Émile Charles LAMBINET (1815–77)
French School
Born at Versailles, he was a pupil of Drolling and Horace Vernet, but he was more influenced by Corot and Daubigny. From 1833 to 1876 he exhibited landscapes in the Paris Salon. Lambinet was admired by Henry James and one of his landscapes sets the stage for the final crisis in *The Ambassadors* (see H. James, *The painter's eye*, ed. J. L. Sweeney, 1956, p. 28 f.).

132
LANDSCAPE AT ÉCOUEN, NEAR PARIS
Signed and dated lower right
Emile Lambinet 1858
Panel
$21 \times 17\frac{1}{2}$ (53·3 × 44·5)
Forster Bequest
F.17

Condition. Vertical division visible at join in panel.
Prov. Bought by John Forster at the Gallery of Fine Arts in 1858 for £47 5s. (see Forster Collection MSS, x, nos. 21–2); bequeathed to the Museum in 1871.
Exh. The French School of art, Gallery of Fine Arts, 1858, no. 85.
Lit. Forster Collection Catalogue, 1893, p. 3; V. & A. Museum, *French paintings*, 1971, pl. 31.

Arie Johannes LAMME (1812–1900)
Dutch School
Born in Dordrecht, he was a pupil of his father Arnoldus and also of his cousins Ary and Henri Scheffer in Paris in 1829. He painted mainly portraits and genre scenes and illustrations of the Dutch wars of independence. As well as a painter, he was an art dealer and the first director of the Boymans Museum in Rotterdam (1852–70).

133
MEDITATION: A LADY LOOKING OUT
OF A WINDOW
Signed lower right *A. J. Lamme*
Canvas
$19\frac{1}{4} \times 12\frac{5}{8}$ (49 × 32)
Dixon Bequest
1072–1886

Prov. Joshua Dixon; bequeathed to Bethnal Green Museum in 1886.

Jean Pierre François LAMORINIÈRE (1828–1911)
Belgian School
Lamorinière was a pupil of Iacob Jacobs in Antwerp, where he lived most of his life, and where he taught at the Academy. He painted mainly landscapes.

134
LANDSCAPE WITH FISHERMAN AND
BOAT
Signed and dated lower right
F.cois Lamorinière 1872
Panel
$26\frac{3}{4} \times 33\frac{7}{8}$ (67·9 × 86)
Dixon Bequest
1084–1886

Prov. Joshua Dixon; bequeathed to Bethnal Green Museum in 1886.
Lit. Shaw Sparrow, 1892, p. 160.

Carl Joseph LASCH (1822–88)
German (Düsseldorf) School
Born at Leipzig, he was a student at the Dresden Academy, and then a

pupil of Schnorr von Carolsfeld and Kaulbach in Munich. He visited Rome in 1847, was in Moscow from 1847 to 1857 and a student of Couture in Paris in 1857–59. In 1860 he settled in Düsseldorf. He painted interiors, portraits and landscapes, concentrating on genre scenes in the latter part of his career.

135
COUNT EBERHARD CUTTING THE
TABLE-CLOTH
Signed and dated lower right
C. Lasch 1847
Canvas
$37\frac{1}{2} \times 30\frac{1}{4}$ (95·2 × 76·8)
Townshend Bequest
1542–1869

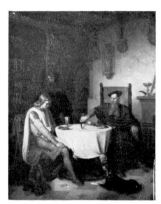

This scene occurs in *Graf Eberhart der Rauschebart*, a ballad by the German Romantic poet Ludwig Uhland (1787–1862). Eberhard II, Count of Württemberg (1315–92), speaks harshly to his son for retreating before a more numerous enemy and leaving the battlefield alive. He cuts the table-cloth in order to separate himself from his son.

The same subject appears on a painting of c. 1850 by Ary Scheffer (L. Vitet, *Oeuvre de Ary Scheffer*, 1860, pl. 45).

Condition. The paint surface has flaked considerably.
Prov. The Rev. C. H. Townshend; bequeathed to the Museum in 1868.

Alphonse LEGROS (1837–1911), see *Catalogue of British paintings*

Eugène Modeste Edmond LE POITTEVIN (1806–70)
French School.
Born in Paris, where he lived all his life, he painted genre scenes, landscapes and sea views and was also active as a graphic artist and illustrator.

136
ROCKY COAST NEAR LE HAVRE:
SUNSET
Signed and dated lower left
ELP (in monogram) *1839*
Canvas
$10\frac{3}{4} \times 14$ (27·3 × 35·5)
Townshend Bequest
1570–1869

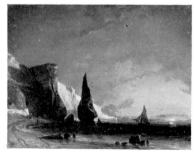

Prov. The Rev. C. H. Townshend; bequeathed to the Museum in 1868.

Baron Jan August Hendrik LEYS (1815–69)
Belgian School
Born at Antwerp and a student at the Academy there, he visited Delacroix
in Paris in 1835 and his early career is dominated by Romanticism in style
and subject. From about 1840 he painted in a more naturalistic manner, at
first under the influence of Rembrandt and De Hooch; later under that of
Courbet and Millet.

137
THE KNIGHT'S FUNERAL
Mahogany panel
22⅜ × 18 (56·8 × 45·7)
Townshend Bequest
1560–1869
Not reproduced

Condition. The picture is completely disfigured owing to the running of thick
layers of bitumen. A photograph taken in 1918 shows that there has been little
change since that date.
Prov. The Rev. C. H. Townshend; bequeathed to the Museum in 1868.

Léon Augustin L'HERMITTE (1844–1925)
French School
Born at Mont-Saint-Père, near Château-Thierry, he was a pupil of H.
Lecoq de Boisbaudran in Paris. He painted mainly rustic scenes with
peasants, which he exhibited at the Paris Salon from 1864. He was in
London in 1871–72 and thereafter settled in Paris again. In 1910 he
became a Commander of the Legion of Honour.

138
THE MARKET PLACE OF
PLOUDALMEZEAU, BRITTANY
Signed and dated lower right
L. Lhermitte – 77
Canvas
15¾ × 22½ (40 × 57·2)
Ionides Bequest
CAI.68

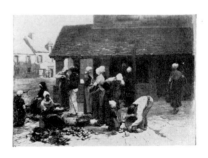

Prov. Constantine Alexander Ionides before 1884; bequeathed to the Museum in
1900.
Lit. Monkhouse, 1884, p. 126, repr.; Long, *Cat. Ionides Coll.*, 1925, p. 38.

139
LE PARDON DE PLOURIN, BRITTANY:
PEASANTS LEAVING CHURCH
Signed lower left *L. Lhermitte*
Canvas
16 × 22¾ (40·6 × 57·8)
Ionides Bequest
CAI.69

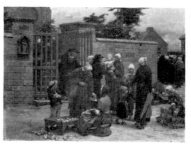

Prov. Constantine Alexander Ionides; bequeathed to the Museum in 1900.
Lit. Long, *Cat. Ionides Coll.*, 1925, p. 38.

Georg Emil LIBERT (1820–1908)
Danish School
Born in Copenhagen, where he was a pupil at the Academy, he was in
Munich in 1846–47 and in Southern Germany and Austria in 1851,
1857–59 and 1875. He painted mainly landscapes and street scenes.

140
FROST SCENE: THE SETTING SUN
Signed and dated lower right
G. Emil Libert, 1847 M[ünchen].
Canvas
36½ × 51 (92·7 × 129)
Townshend Bequest
1577–1869

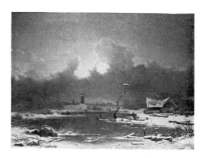

Prov. The Rev. C. H. Townshend; bequeathed to the Museum in 1868.

141
SNOW SCENE: THE HAUNTED HOUSE
Signed and dated lower right
G. Emil Libert 1847
Canvas
9½ × 13¼ (24 × 34)
Townshend Bequest
1571–1869

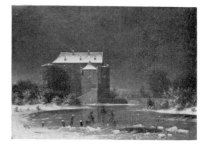

An earlier and smaller version of 1573–1869 (no. 142). There are fewer
figures and no boat, there is some difference in the trees on the right and the
tone is darker, but otherwise it is very close in character and composition
to the later version.
Prov. The Rev. C. H. Townshend; bequeathed to the Museum in 1868.

142
SNOW SCENE: THE HAUNTED HOUSE
Signed and dated lower right
G. Emil Libert 1848 München
Canvas
25 × 32¾ (63·5 × 83·2)
Townshend Bequest
1573–1869

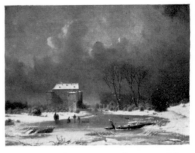

A larger version of the scene painted in the previous year (1571–1869; no. 141). Apart from the increased scale, the composition has been enlarged slightly at the sides and considerably in the sky. It is uncertain whether Libert was still in Munich in 1848 (the dates of his first visit are given as 1846–47 in Thieme-Becker) or whether this version was painted from 1571–1869 after his return to Denmark.

Prov. The Rev. C. H. Townshend; bequeathed to the Museum in 1868.

143
SUNSET ON A BAY, WITH CASTLE RUINS
Signed and dated lower right
Georg Libert 1848
Canvas
43 × 57½ (109·2 × 146)
Townshend Bequest
1553–1869

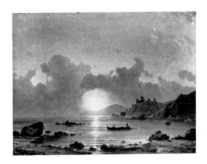

Prov. The Rev. C. H. Townshend; bequeathed to the Museum in 1868.

144
MOUNTAIN STREAM
Signed lower right *G. Emil Libert*
Canvas
10¾ × 14½ (27·3 × 36·8)
Townshend Bequest
1562–1869

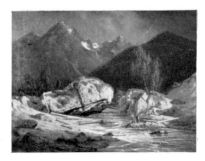

Prov. The Rev. C. H. Townshend; bequeathed to the Museum in 1868.

145
COAST SCENE: GULF OF LYONS
Canvas, mounted on card
$9\frac{1}{4} \times 13\frac{1}{8}$ $(23\frac{1}{2} \times 33\frac{1}{2})$
Townshend Bequest
1633–1869

Prov. The Rev. C. H. Townshend; bequeathed to the Museum in 1868.

Johann Wilhelm LINDLAR (1816–96)
German School
A pupil of J. W. Schirmer, he was a landscape painter living in Düsseldorf.

146
A MOUNTAIN TORRENT
Signed and dated 1860
Canvas
$42\frac{1}{2} \times 33\frac{1}{2}$ (108×85)
500–1870
Not reproduced
Prov. John Parsons; bequeathed to the Museum in 1870.

Charles Antoine Joseph LOYEUX (1823–98 ?)
French School
Born in Paris, he was a pupil of P. Delaroche. He painted portraits and
genre scenes and exhibited in the Salon from 1842 until 1882.

147
INTERIOR OF A SPANISH POSADA
Signed and dated lower right
C. LOYEUX 1864
Canvas
$44\frac{3}{4} \times 49\frac{5}{8}$ (113.7×126)
Dixon Bequest
1051–1886

Prov. Joshua Dixon; bequeathed to Bethnal Green Museum in 1886.

Albert LUGARDON
Swiss School
Born in Rome, he was the son and pupil of Jean Léonard Lugardon, and
also the pupil of Calame and Ary Scheffer. He lived in Geneva and
painted mainly Alpine scenes.

148
THE WHITE COW
Signed lower right *Albert Lugardon*
Panel
12¾ × 16 (32·4 × 40·5)
Townshend Bequest
1544–1869

Prov. The Rev. C. H. Townshend; bequeathed to the Museum in 1868.

Jean Leonard LUGARDON (1801–84)
Swiss School
He was born in Geneva, where he spent most of his life, apart from a visit
to Rome in 1826–29.

149
THE WOUNDED TRAVELLER HALTING
Signed on rock to the right of the
man's staff *Lugardon*
Canvas
26¾ × 19¾ (67·5 × 50·5)
Townshend Bequest
1606–1869

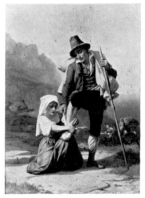

The landscape is traditionally said to be by Alexandre Calame (1893
Catalogue, p. 167). There is no firm evidence for this, but it is inherently
not unlikely: Lugardon was a close friend of Calame and there are examples
of his painting figures in Calame's landscapes (E. Rambert, *Alexandre
Calame*, 1884, p. 540). On the other hand it must be admitted that the
landscape in 1606–1869 is not strikingly similar to Calame's usual style.
Prov. The Rev. C. H. Townshend; bequeathed to the Museum in 1868.

Jozef van LUPPEN (1834–91)
Belgian (Antwerp) School
Born in Antwerp, he was a pupil of J. Jacobs and Nicaise de Keyser in

Antwerp and of Théodore Rousseau in Paris. He painted mainly land-scapes.

150
VIEW IN MOYLAND NEAR CLEVES,
GERMANY
Signed and dated lower right
Joseph van Luppen 69
Canvas
$52\frac{1}{8} \times 72$ (130 × 183)
Dixon Bequest
1053–1886

Prov. Joshua Dixon; bequeathed to Bethnal Green Museum in 1886.

Carl Freiherr von MALCHUS (1835–89)
German (Munich) School
Born at Ludwigsburg he was an officer in the Austrian army until 1866, then lived in Munich. He painted mainly landscapes.

151
VENICE: THE DOGE'S PALACE AND THE
RIVA DEGLI SCHIAVONI
Signed and dated lower right
C v Malchus 1881
Canvas
$31\frac{3}{4} \times 50\frac{5}{8}$ (80·7 × 128·6)
Dixon Bequest
1047–1886

Prov. Joshua Dixon; bequeathed to the Bethnal Green Museum in 1886.

Antoine MARGRY (exhibited 1831–47)
French School
A painter of flowers and fruit pieces, he exhibited at the Paris Salon from 1831 to 1847.

152
FLOWERS IN A VASE
Signed and dated lower right
A Margry 1849
Canvas, stuck behind glass
Oval, $6\frac{7}{8} \times 5\frac{3}{4}$ (17·5 × 14·6)
60–1908

Prov. Mrs Elizabeth South; given to the Museum in 1908.

Matthijs MARIS (1839–1917)
Dutch School
Born at The Hague, the brother of Jacobus and Willem Maris, he was a
student at the Academies at The Hague and in Antwerp, where he shared
rooms with Alma Tadema. In 1860 he travelled in Germany and Switzer-
land and came under the influence of German Romanticism. He lived in
Paris 1867–72 and in London from 1877 until his death in 1917.

Lit. H. E. van Gelder, *Matthijs Maris*, Amsterdam, c. 1946.

153
THE HAY CART: EFFECT OF DAWN OR
TWILIGHT
Signed and dated in red lower right
MM 60
Paper laid on oak panel
$11\frac{7}{8} \times 6\frac{3}{4}$ (30 × 17)
Ionides Bequest
CAI.90

This painting was accepted without question as a work by Maris until Sir
Charles Holmes' publication of it (1906–07), in which he inserted a
footnote to the effect that 'M. Van Wisselingh's recent investigations have
proved that (t)his painting is not by Maris but an enlargement of an
existing original from his hand.' M. Van Wisselingh's investigations were
never published, but, doubts having been raised, the picture was catalogued
as 'by or after Maris' by Long in 1925.

A recent review of the problem by Dr H. A. Tellegen of the Netherlands
Institute for Art History (written communication 1971) has not supported
the doubts raised in 1906. The firm of Van Wisselingh has confirmed that
they sold a small sketch of this composition (10·5 × 18 cm.) to Mrs
Groesbeek, Amsterdam in 1929, but this does not in itself cast any doubt
on the autograph nature of CAI.90. The existence of a further painting
entitled *Le Voiturier* (28·5 × 38·5 cm.; sold at Boussod, Valadon, The
Hague, Nov. 1903) indicates that Maris probably painted this subject
several times.

Stylistically, CAI.90 fits well with Maris's early work of the Dutch period
and may be compared, for example, with the *Painter* in the Stedelijk
Museum, Amsterdam, of c. 1863 (repr. Van Gelder, *op. cit.*, p. 11).

Condition. Paper separating from support in upper areas.
Prov. Messrs Buck & Reid (label on back); Constantine Alexander Ionides;
bequeathed to the Museum in 1900.
Lit. Sir C. Holmes, 'The landscapes of Matthew Maris' in *Burl. Mag.*, x, 1906–07,
p. 353, repr. p. 349; Long, *Cat. Ionides Coll.*, 1925, p. 39.

Barthélémy MENN (1815–93)
Swiss (Geneva) School
A native of Geneva, he was a pupil of Ingres in Paris in 1833, and followed

him to Rome in 1835. He was in Paris again from 1838, where he became
a friend of Delacroix, Théodore Rousseau, Daubigny and Corot, all of
whom exerted influence on his work. Returning to Geneva in 1843, he
became the principal link between the Barbizon school and Swiss landscape
painting.

Lit. A. Lanicca, *Barthélémy Menn*, 1911; D. Baud-Bovy, *Barthélémy Menn choix
de lettres* (Zürcher Kunstgesellschaft Neujahrsblatt, 1924).

154
CHILDREN PLAYING WITH A LAMB
Signed lower left *B Menn*
Paper on cardboard
9 × 12¾ (22·9 × 32·4)
Townshend Bequest
1598–1869

This, and the following numbers, belong to Menn's outdoor genre scenes
or 'Idylls', which formed an important part of his work in the late 1840s
and 1850s.

Prov. The Rev. C. H. Townshend; bequeathed to the Museum in 1868.

155
CHERRIES: A GROUP OF YOUNG
WOMEN IN A LANDSCAPE, ONE OF
THEM HOLDING A BASKET OF CHERRIES
Signed lower left *B Menn*
Millboard
7¾ × 11¼ (19·7 × 28·5)
Townshend Bequest
1599–1869

Prov. The Rev. C. H. Townshend; bequeathed to the Museum in 1868.

156
THE MIST: CHILDREN ROUND A FIRE
Signed lower left *B. Menn*
Canvas
16¾ × 14 (42·5 × 35·5)
Townshend Bequest
1600–1869

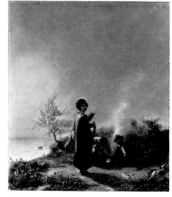

Prov. The Rev. C. H. Townshend; bequeathed to the Museum in 1868.

157
THE SPRING
Signed lower left *B Menn*
Paper on cardboard
8 × 11½ (20·3 × 29·2)
Townshend Bequest
1601–1869

Prov. The Rev. C. H. Townshend; bequeathed to the Museum in 1868.

158
CATCHING FROGS
Signed lower left *B Menn*
Paper on cardboard
8 × 11½ (20·3 × 29·2)
Townshend Bequest
1602–1869

Prov. The Rev. C. H. Townshend; bequeathed to the Museum in 1868.

159
THE COWHERD
Signed lower left *B. Menn*
Paper on cardboard
13 × 11¼ (33 × 28·6)
Townshend Bequest
1611–1869

Prov. The Rev. C. H. Townshend; bequeathed to the Museum in 1868.

Louis MENNET (1829–75)
Swiss School
Born in Geneva, where he spent most of his life, he was a pupil of Diday
and Calame. He painted mainly seascapes.

160
LAKE OF GENEVA
Signed lower left *L. Mennet*
Canvas
29 × 40½ (73·7 × 103)
Townshend Bequest
1619–1869

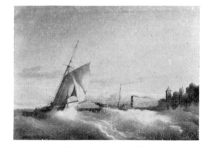

Prov. The Rev. C. H. Townshend; bequeathed to the Museum in 1868.

Georges MICHEL (1763–1843)
French School
Born at Paris in 1763, he was influenced by Dutch 17th century landscape
painters and is regarded as a precursor of Rousseau. His landscapes are
chiefly derived from the environs of Paris. He exhibited at the Salon from
1791 to 1814 and continued to paint until his death in 1843.

161
THE MILL
Panel
18⅛ × 14⅞ (46 × 37·7)
Ionides Bequest
CAI.67

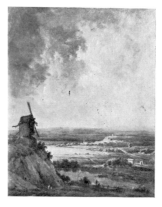

The windmill is a common feature in Michel's paintings, but the upright
format is unusual.

Prov. Constantine Alexander Ionides; bequeathed to the Museum in 1900.
Lit. Sir. C. Holmes in *Burl. Mag.*, vi, 1904–05, p. 26 f., repr.; C. L. Hind, *Land-
scape painting from Giotto to the present day*, i, 1923, p. 234, repr.; Long, *Cat.
Ionides Coll.*, 1925, p. 40.

Jean-François MILLET (1814–75)
French School
Born in Normandy of peasant stock Millet's first professional training was
acquired in Cherbourg under the painters Mouchal and Langlois in
1833–36. He went to Paris in 1837, where he was a pupil of Paul Delaroche,
and for the next ten years painted mainly portraits and *scènes galantes* in the
manner of Diaz. At about the time of the Revolution of 1848, he turned
increasingly to painting rural scenes; in 1849 he moved to Barbizon, where
he became a close friend of Théodore Rousseau, and where he remained for
the rest of his life. Although attacked for his concentration on peasant
subjects, he won increasing public recognition in the 1860s, and was
awarded the Legion of Honour in 1868.

Lit. E. Moreau-Nélaton, *Millet raconté par lui-même*, Paris, 1921; R. L. Herbert,
Barbizon revisited, New York, 1963; *ibid.*, *Millet* (in preparation).

162
THE WOOD SAWYERS
Canvas
$22\frac{1}{2} \times 32$ (57×81)
Ionides Bequest
CAI.47

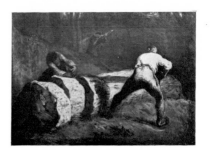

The similarities with Daumier have frequently been stressed (*Athenaeum*, 1904; Sir C. Phillips, 1923) but the suggestion, never very convincing, that the painting is in fact by Daumier and not by Millet has been dismissed by the most recent authority (Herbert, 1962).

Millet came under the strong influence of Daumier when he began seriously painting rural genre scenes in the years 1846–52 and *The Wood Sawyers* is one of his early masterpieces in this field. It may be placed not long after the various versions of *The Sower*, painted in 1850 (Herbert, *Barbizon revisited*, p. 150, no. 62).

The preparatory study in black chalk for this composition in the Musée Bonnat, Bayonne, has been dated c. 1850–51 (Herbert, 1962). Two further studies probably related to this composition were exhibited at the Leicester Galleries in November 1921 (nos. 94 & 98). There are two other versions in oils: (1) private collection, Paris, showing two figures instead of three, and the log sawn at one point only; (2) whereabouts unknown (authenticity in dispute), repr. *Der Kunstwanderer*, 1928, p. 75, exh. Beaux Arts Gallery, 1949, closer to (1) in that it shows only two figures, but the log is sawn, at three points as in the V. & A. picture. In view of the fact that the V. & A. picture is only one with the third figure in the background, it seems likely that it is the final version. It may be dated c. 1850–52.

Condition. The canvas was enlarged by the artist by $1\frac{1}{2}$ in. at the bottom and sides; $2\frac{3}{4}$ in. at top. Pentimenti visible, in particular at the left shoulder of the first figure.
Prov. W. E. Henley; Constantine Alexander Ionides, before 1884; bequeathed to the Museum in 1900.
Exh. French and Dutch Loan Collection, Edinburgh International Exhibition, 1886, no. 1131 (no. 83 of *Mem. cat.*); *French and Dutch Romanticists*, Dowdeswell Galleries, 1889, no. 85; Winter Exhibition, R. A., 1896, no. 64.
Lit. Monkhouse, 1884, p. 43, repr. p. 37; *Memorial of the French and Dutch Loan Collection, Edinburgh International Exhibition 1886*, 1888 (repr. of a sketch of it by William Hole, R.S.A.); Anon. in *Athenaeum*, 15 Feb. 1896, p. 223; *Studio*, winter number on Corot and Millet, 1902–03, repr.; P. M. Turner, *Millet*, n. d., pl. vii; A. Tomson, *Jean François Millet and the Barbizon School*, 1903, repr. facing p. 66; Anon. in *Art Journal*, 1904, p. 285, repr.; Anon. in *Athenaeum*, 23 July 1904, p. 119; F. Rutter in *L'Art et Les Artistes*, v, 1907, p. 7; Long, *Cat. Ionides Coll.*, 1925, p. 41, pl. 22; J. Rothenstein, *Nineteenth century painting*, 1932, p. 136, repr.; R. L. Herbert in *Burl. Mag.*, civ, 1962, p. 301; V. & A. Museum, *The Barbizon School*, 1965, p. 18, pl. 11.

163
THE SHEPHERDESS
Signed lower right, *J. F. Millet*
Canvas
8 × 12⅝ (20·3 × 32)
Ionides Bequest
CAI.48

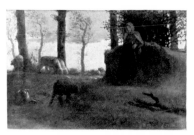

Dated c. 1853–54 in the Millet sale, but R. L. Herbert's suggested date, 1851, carries greater conviction. There is a preparatory drawing in the Museum of Fine Arts, Boston (black chalk, 19·9 × 31 cm., Millet sale, no. 126).

Condition. Prominent surface cracks.
Prov. Millet sale, Paris, 10 May 1875, lot 6, 3,300 francs; Goupil & Co. (label on back); Constantine Alexander Ionides before 1884; bequeathed to the Museum in 1900.
Exh. French and Dutch Loan Collection, Edinburgh International Exhibition, 1886, no. 1124 (no. 77 of *Mem. cat.*); *French and Dutch Romanticists*, Dowdeswell Galleries, 1889, no. 83.
Lit. Monkhouse, 1884, p. 43, repr.; A. Tomson, *Jean François Millet and the Barbizon School*, 1903, repr. facing p. 18; L. Soullié, *Les grande peintres aux ventes publiques*, ii, *Jean-François Millet*, 1900, p. 4; Long, *Cat. Ionides Coll.*, 1925, p. 42, pl. 23; V. & A. Museum, *The Barbizon School*, 1965, p. 19, pl. 12.

164
THE WELL AT GRUCHY
Canvas
15¾ × 12¾ (40 × 32·4)
Ionides Bequest
CAI.49

Painted by Millet on a visit to his childhood home at Gruchy, near Cherbourg in the summer of 1854. A photograph of the actual well and steps is reproduced in Moreau-Nélaton, iii, fig. 310.

This painting combines two themes dear to Millet: the peasant woman filling pitchers at the well, of which this is an early example, and the portrayal of his family house at Gruchy. Although this appears to be the only extant oil painting of this house, there are several pastels and drawings with variant compositions. A pastel in the Musée de Lyon (formerly van den Eynde and Tabourier collections) has the same frontal viewpoint as the oil painting, but it contains no figures and is a later work. Two pastels in the Museums at Boston and Montpellier show the house and well from a different viewpoint, further to the right, and the woman feeding geese.

Finally, a third type (formerly Feuerdant collection, Drouot sale, 23 Mar. 1934, lot 47, and cf. Boston Museum of Fine Arts, no. 61.625) has the same angle of vision as the Boston/Montpellier composition, but is similar to the V. & A. painting in that the woman is shown pouring water at the well.

Prov. Millet sale, Paris, 10 May 1875, lot 12; bought Durlacher for 2.300 francs; Henry Hill Brighton; sold Christie's, 25 May 1889, lot 39, bought Buck & Reid £78 15s; Constantine Alexander Ionides; bequeathed to the Museum in 1900.
Lit. Soullié, *Ventes . . . Millet*, 1900, p. 25; A. Tomson, *Jean-François Millet and the Barbizon School*, 1903, repr. facing p. 70; E. Moreau-Nélaton, *Millet raconté par lui-même*, ii, 1921, p. 13, fig. 105; Long, *Cat. Ionides Coll.*, 1925, p. 42; R. Pickvance, 'Henry Hill: an untypical Victorian collector' in *Apollo*, 1962, p. 791, fig. 1; V. & A. Museum, *The Barbizon School*, 1965, p. 19, pl. 14.

165
LANDSCAPE WITH A TERMINAL FIGURE
Canvas
18 × 15 (46 × 38)
Ionides Bequest
CAI.172

R. L. Herbert has identified this painting with no. 29 in the Millet sale, *Étude pour le Tableau du Printemps*. The 'Spring' referred to is one of the four seasons commissioned in 1864 for M. Thomas, Duc de Bojano, for his city house in Paris. Installed in September 1865 the series was later dispersed; 'Spring' is now in the Matsukata Collection, National Museum of Western Art, Tokyo (oil on canvas, 231.5 × 131.5 cm.). The finished version contains the figures of Daphnis and Chloë, which do not appear in the V. & A. landscape. It represents the coast near Cherbourg, the subject of many of Millet's paintings, but, as he paid no visits to his old house between 1854 and 1870, it could not have been taken direct from nature. It is doubtful whether the terminal figure could actually have been found there; it was probably added because of the Daphnis and Chloë theme. This sketch may reasonably be dated 1864 or slightly earlier.

Prov. Seal *Vente J. F. Millet* at back; Millet sale, Paris, 10 May 1875, lot 29 sold for 1,210 francs; Collection Henry Hill, Brighton; sold Christie's, 25 May 1889, bought Dowdeswell, 12 gns.; Buck & Reid; Constantine Alexander Ionides; bequeathed to the Museum in 1900.
Lit. Soullié, *Ventes . . . Millet*, 1900, p. 32; Long, *Cat. Ionides Coll.*, 1925, p. 43; R. Pickvance, 'Henry Hill: an untypical Victorian collector' in *Apollo*, 1962, p. 791; V. & A. Museum, *The Barbizon School*, 1965, p. 19, pl. 15.

MOLL, Evert (1878–1955)
Dutch School
Born at Voorbug, Holland, he became a land- and seascape painter under
the influence of Willem Maris and A. Roelofs. From about 1899 until 1904
he lived in London and, after a brief stay in Paris, settled in Dordrecht
in 1906.

166
DUTCH RIVER SCENE
Signed lower right *Evert Moll*
Panel
$11\frac{1}{2} \times 7\frac{7}{8}$ (29·2 × 20)
P.47–1919

Prov. B. H. Webb; bequeathed to the Museum in 1919.

Elie Honoré MONTAGNY (active before 1805; d. 1864)
French School; worked in Naples
Born in Paris, he was a pupil of David and became a history painter. After
completing his studies he visited Rome, Naples and, in 1805, Sicily. He
subsequently became court painter to Queen Caroline of Naples.

167
TASSO READING BEFORE THE DUKE OF
FERRARA
Signed and dated lower left
E. H. MONTAGNY. PINXIT.
NAPOLI. 1815
Canvas
$22\frac{3}{4} \times 29\frac{3}{4}$ (63·7 × 75·5)
Dixon Bequest
1059–1886

Torquato Tasso (1544–95) entered the service of the Count of Ferrara –
perhaps the most brilliant in 16th century Italy – in 1565. In the summer of
1575 he read his recently completed epic poem *Gerusalemme Liberata* to
Alfonso II d'Este, Duke of Ferrara, and Princess Lucrezia. The subject is
exceedingly rare in 19th century painting.
Prov. Joshua Dixon; bequeathed to Bethnal Green Museum in 1886.

Henri Auguste d'Ainecy, Comte de MONTPEZAT (1817–59)
French School
Born in Paris, he was a pupil of Dubonloz. He painted mainly portraits,
hunting scenes and pictures of horses.

168
AN 18TH CENTURY HUNTING SCENE
Signed lower right *MONTPEZAT*
Canvas
$25\frac{1}{2} \times 35\frac{1}{2}$ (64·8 × 90·2)
S.Ex.191–1886

Prov. Bought as one of a series of 'schools examples', which were circulated to schools for use in art classes, from H. Selwyn in 1886.

Christian Ernst Bernhard MORGENSTERN (1805–67)
German (Munich) School
Born in Hamburg, the son of the miniature painter Johann Heinrich Morgenstern, he studied art in Hamburg and at the Academy in Copenhagen (1827–28). In 1829 he settled in Munich and became one of the leading landscape painters of the Munich school. He is known as a Realist, but he was also influenced by the Romanticism of Rottmann, and his work often verges on the theatrical.

169
ALPINE LANDSCAPE
Signed and dated lower left
Chr. Morgenstern 1847
Canvas
$26\frac{1}{2} \times 33\frac{1}{2}$ (67·3 × 85·2)
Townshend Bequest
1546–1869

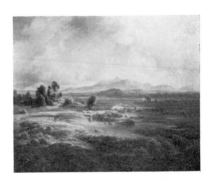

Waagen described this painting as 'true in conception, of great effect in lighting, and carefully executed.'

Prov. Acquired by the Rev. C. H. Townshend before 1854–56, when it was seen in his dining room by Waagen; bequeathed to the Museum in 1868.
Lit. Waagen, *Supplement*, 1857, p. 177.

Ludwig MUNTHE (1841–96)
Norwegian School; worked in Düsseldorf
Born in Norway, he was a pupil of F. W. Schiertz in Bergen, and from 1861 at the Düsseldorf Academy. He specialized in beach views and winter landscapes.

170
WINTER SCENE: SUNSET
Signed lower right *L. Munthe*
Canvas
13¾ × 21 (34·9 × 53·3)
Dixon Bequest
1063–1886

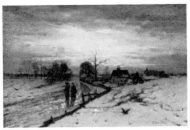

Prov. Joshua Dixon; bequeathed to Bethnal Green Museum in 1886.

171
WINTER LANDSCAPE: SUNSET
Signed lower right *L. Munthe*
Canvas
20½ × 34⅜ (69·8 × 87·3)
Dixon Bequest
1080–1886

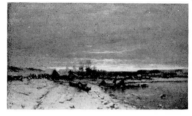

Prov. Joshua Dixon; bequeathed to Bethnal Green Museum in 1886.

Alfred van MUYDEN (1818–98)
Swiss School
Born in Lausanne, he was a pupil of Kaulbach in Munich from 1838. He
was in Rome 1842–49, in Lausanne 1849–51 and again in Rome 1851–56.
In 1856 he settled in Champel, near Geneva, and in the following year
became founder of the Geneva Société des Amis des Beaux Arts. He
painted genre scenes, animal subjects and portraits.

172
A MONK READING
Signed lower right *A. van Muyden*
Canvas
15¾ × 12¾ (40 × 32·4)
Townshend Bequest
1618–1869

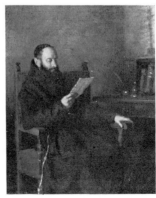

Prov. The Rev. C. H. Townshend; bequeathed to the Museum in 1868.

Hugo OEHMICHEN (b. 1843)
German (Düsseldorf) School
Essentially a genre painter, he was born at Borsdorf near Leipzig, became a

pupil at the Dresden academy and, after a study visit to Italy in 1866–67, settled in Düsseldorf in 1869.

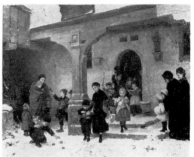

173
CHRISTMAS PRESENTS: CHILDREN
LEAVING A CONVENT SCHOOL
Signed and dated lower right
Hugo Oehmichen 1882
Canvas
36½ × 45⅛ (92·7 × 114·5)
Dixon Bequest
1052–1886

A similar subject appears on a painting by Oehmichen dated 1865, in the Leipzig Gallery.

Prov. Joshua Dixon; bequeathed to Bethnal Green Museum in 1886.

Balthasar Paul OMMEGANCK (1755–1808)
Netherlandish (Antwerp) School
Born at Antwerp, where he was a pupil of H. J. Anthonissen, he became a painter of landscape, animals and portraits. From 1796 he taught at the Antwerp Academy.

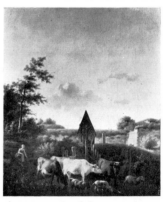

174
LANDSCAPE WITH CATTLE
Signed and dated lower right
B. P. Ommeganck 1808
Panel
14½ × 12 (36·7 × 30·5)
570–1870

Condition. The paint surface is marred by an extensive network of deep cracks.
Prov. John Parsons; bequeathed to the Museum in 1870.

Félix Henri Emmanuel PHILIPPOTEAUX (1815–84)
French School
Born in Paris, he was a pupil of L. Cogniet. He painted portraits as well as history subjects and is also known as a graphic artist and illustrator.

175
THE BATTLE OF FONTENOY, 1745:
THE FRENCH AND THE ALLIES
CONFRONTING EACH OTHER
Signed and dated lower right
F. Philippoteaux 1873
Canvas
28¼ × 45¾ (71·8 × 116·2)
85–1880

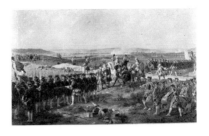

At the battle of Fontenoy near Tournai, fought on 11 May 1745, during the War of the Austrian Succession, the French, under Marshal Saxe, defeated the Allies (English, Hanoverians, Dutch and Austrians) commanded by the Duke of Cumberland. The painting shows the pause in the battle when the two sides were face to face, and Capt. Lord Charles Hay of the Grenadier Guards suddenly ran in front of the line, took off his hat to the enemy and drank to them from his pocket flask shouting 'We hope you will stand till we come up to you and not swim the river as you did at Dettingen.' He then called for three cheers, whereupon the French, shown in the foreground of the painting, gave three counter cheers. The three horsemen on the French side may be interpreted as Louis XV and the Dauphin, who were present at the battle, and the commander, Marshal Saxe.

Prov. Given to the Museum by F. R. Bryan in 1880 together with 84–1880 (no. 176).

176
THE BATTLE OF WATERLOO: THE
BRITISH SQUARES RECEIVING THE
CHARGE OF THE FRENCH CUIRASSIERS
Signed and dated lower right
F. Philippoteaux 1874
Canvas
39 × 61 (99 × 155)
84–1880

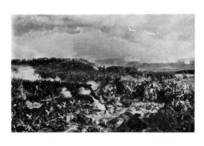

The scene has been identified by Commandant Lachouque (in a letter to the Museum) as representing the British 5th Division under Sir Thomas Picton (which included several Highland Regiments) receiving in square the 5th and 10th Cuirassiers at Waterloo on 18 June 1815 (the Cuirassiers' saddle rolls bear the number 5). The painting was described by Ruskin in 1875 as 'this carefully-studied and skilful battle piece'. There is an oil sketch for this composition in the Museum (P.1–1935: no. 177).

Prov. Presumably bought by F. R. Bryan in or shortly after 1875 and given by him to the Museum in 1880.
Exh. R.A. 1875, no. 613; British Empire Exhibition, Wembley, 1924.
Lit. Ruskin on pictures, ed. E. T. Cooke, ii, 1902, p. 261 (description of the R. A. exhibition, 1875).

177
THE BATTLE OF WATERLOO: THE
BRITISH SQUARES RECEIVING THE
CHARGE OF THE FRENCH CUIRASSIERS
Signed lower centre
F. Philippoteaux . . .
Oil sketch on paper on canvas
$17\frac{5}{8} \times 22\frac{1}{2}$ ($44\cdot7 \times 57$)
P.1–1935

Sketch for the larger, finished version (84–1880: no. 176), which follows it closely.

Prov. Bruce Ingram; given to the Museum in 1935.

178
THE YOUNG LOUIS XV AT VERSAILLES
Signed lower right
F. PHILIPPOTEAUX
Panel
$14\frac{3}{4} \times 18$ ($37\cdot5 \times 45\cdot7$)
1581–1904

Prov. F. R. Bryan; given to the Museum in 1904.

Otto PILTZ (1846–1910)
German School
Born at Allstedt near Weimer, he was a pupil of Kalck Veuth at the Weimar Academy and became professor there in 1882. From 1889 he lived in Munich. He painted mainly genre scenes.

179
THE QUINTET
Signed lower left *O. Piltz*
Mahogany panel
$23\frac{1}{4} \times 28\frac{3}{4}$ ($59\cdot1 \times 73$)
P.70–1917

Prov. Perhaps identical with *Musiklehrlinge in einem Dachkammer bei Ausübung ihres Berufs* (60 × 74 cm.), sold Lepke, Berlin, 25 Oct. 1892; Henry L. Florence; bequeathed to the Museum in 1917.

Johann Wilhelm PREYER (1803–89)
German (Düsseldorf) School
Born at Rheydt near Gladbach, he studied at the Düsseldorf Academy
under P. von Cornelius and W. von Schadow from 1882. After travelling to
Munich, Italy and Holland, he settled in Düsseldorf in 1843. He is
considered to be the most important German still life painter of the 19th
century.

180
STILL LIFE: FRUIT AND GOBLET
Signed and dated lower right
J W Preyer 1854 (initials in mono-
gram)
Canvas
15½ × 13½ (39·4 × 34·3)
Jones Bequest
579–1882

Prov. John Jones; bequeathed to the Museum in 1882.
Lit. Long, *Cat. Jones Coll.*, 1923, p. 37.

Louis PULINCKX (active 1843–after 1879)
Belgian School
A Belgian landscape painter, he was a pupil of Carot in Paris and sub-
sequently worked in Paris and Antwerp.

181
VIEW ON THE SCHELDT
Signed and dated lower right
Louis Pulinckx 75
Canvas
56¾ × 78¼ (144 × 198·7)
Dixon Bequest
1075–1886

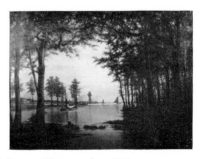

Prov. Joshua Dixon; bequeathed to Bethnal Green Museum in 1886.
Lit. Shaw Sparrow, 1892, p. 163.

Pierre-Cécile PUVIS DE CHAVANNES (1824–98)
French School
Born at Lyons, he was a pupil of Henri Scheffer in Paris and for a short

time of Couture and Delacroix. He was greatly influenced by Chassériau and painted many large mural paintings.

182
CHARITY; A SKETCH: A WOMAN
DISTRIBUTING GIFTS TO TWO WINGED
CHILDREN
Canvas
112 × 56 (284·5 × 142·2)
E.917–1911

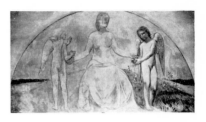

There are only two colours: the figures and ground are pale purple, the background is orange. This is an apparently unfinished cartoon for one of Puvis de Chavannes' wall paintings on the *Escalier d'honneur sud* or Prefects' staircase in the Hotel de Ville, Paris. The central composition is entitled *Victor Hugo offering his lyre to the City of Paris* and there are a number of allegories: *Charity, The Inspiration of the Artist, Study, Patriotism, Wit, Beauty, Refinement, Fearlessness, The Culture of Memory, Fantasy*, which are said to represent the virtues of the Parisians. Painted between 1889 and 1893, these form one of the artist's last major decorative schemes.

This is somewhat unusual rendering of Charity, who is usually shown surrounded by several small children (cf. E. Wind, 'Charity' in *J. W. C. I.*, i, 1939, pp. 322–30).

Prov. Bought by the National Art-Collections Fund in 1911 to give to the Museum.
Exh. French Symbolist painters, Arts Council, Hayward Gallery, 1972, no. 227.
Lit. National Art-Collections Fund, Fourth Annual Report, 1911, p. 40, repr.; V. & A. Museum, *Review of the Principal Acquisitions*, 1911, p. 25, pl. 9. On the original decorative scheme see A. Alexandre, *Puvis de Chavannes*, 1905, p. xvi.

Guillaume REGAMEY (1837–75)
French School
Born in Paris, the son of Frédéric Regamey, the lithographer, he was a pupil of Lecoq de Boisbaudran and of François Bonvin. During the war of 1870 he went to London, where he drew for the *Illustrated London News*. He returned to Paris in June 1871 and died there in January 1875. He specialized in military subjects.

183
A TEAM OF PERCHERON HORSES
Signed and dated lower left
Regamey Guillaume. 70
Canvas
25⅛ × 41½ (63·8 × 105·4)
Ionides Bequest
CAI.71

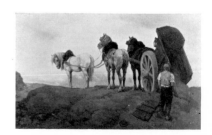

Painted during the artist's stay in England in 1870–71; his address, 41 Addison Gardens, North Kensington, is inscribed on a label on the stretcher.

Prov. Constantine Alexander Ionides before 1884; bequeathed to the Museum in 1900.

Lit. Monkhouse, 1884, p. 120, repr. p. 126 ('The 'Mud-Cart' . . . is a pleasant thought of his less serious moments . . .'); Anon., 'The Constantine A. Ionides Collection' in *Art Journal*, 1904, p. 268 f., repr.; F. Rutter, 'La peinture française à South Kensington' in *L'Art et les Artistes*, v, 1907, pp. 11, 13, repr.; Long, *Cat. Ionides Coll.* 1925, p. 50.

184
THE SENTINEL
Signed and dated lower left
Regamey Guillaume. 1870
Canvas
21¾ × 18 (55·2 × 45·7)
Ionides Bequest
CAI.72

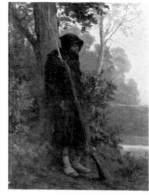

Painted during the artist's stay in England in 1870–71; his address, 6 Holland Road, Kensington, W., is inscribed on the back.

Prov. Constantine Alexander Ionides; bequeathed to the Museum in 1900.

185
ARAB HORSE SOLDIERS
Signed and dated lower left
Regamey Guillaume 71
30 × 41⅜ (76·2 × 105)
Ionides Bequest
CAI.73

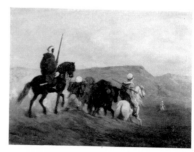

Painted during the artist's stay in England in 1870–71; his address, 6 Holland Road, Kensington, W, is inscribed on the back.

Prov. Constantine Alexander Ionides; bequeathed to the Museum in 1900.

Paul Édouard RISCHGITZ (1828–1909)
Swiss School; worked in Paris
Born in Geneva, where he was a pupil of F. Diday, he subsequently spent much of his working life in Paris. He painted mainly landscapes.

186
VINTAGE ON THE SLOPES OF THE ARVE
NEAR GENEVA
Signed and dated lower right
E. Rischgitz 1857
Canvas
18 × 29½ (45·7 × 75)
Townshend Bequest
1583–1869
Prov. The Rev. C. H. Townshend; bequeathed to the Museum in 1868.

Alessandro RIZZONI (1836–1902)
Italian School
Born in Riga, the son of an Italian soldier in Napoleon's army, he studied at the St Petersburg Academy and then in Paris and Rome in 1862–66. He settled in Rome in 1868 and specialized in scenes of Roman life and pictures of bishops and cardinals.

187
CHURCH OF S. ONOFRIO, ROME: THE
INTERIOR WITH A CARDINAL
Signed and dated lower right
A. Rizzoni 1872 Roma, and again
immediately above, *Roma 187[2 ?]*
A. Rizzoni.
Panel
13¾ × 17⅞ (35 × 46)
Forster Bequest
F.33

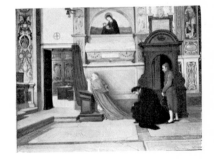

A note by the artist concerning this picture is preserved in the Forster Collection in the Museum Library (MSS, x, p. 2, no. 23):

'L'interno della chiesa del convento di Sant'Onofrio a Roma ove mori il Tasso. La Madonna dipinto al fresco (supra il monumento del Vescovo) è del Pinturicchio, e l'altro fresco a destra è del cavaliere d'Arpino. La scena rappresente il cardinale Barnabo (Prottettore della chiesa) accompagnato del . . . suo segretario e del servitore dopo d'aver assisto allo funzione religiosa.

Roma il 27 Ottobre 1873. Alessandro Rizzoni.'

[The interior of the church of the Convent of St Onofrio in Rome, where Tasso died. The Madonna in the fresco (above the monument of the bishop) is by Pinturicchio, the other fresco on the right is by Cavaliere d'Arpino. The scene represents Cardinal Barnabo (the protector of the church) accompanied by his secretary and his servant after a service].

The fresco of St Anne teaching the Virgin to read is no longer attributed

to Pinturicchio but described more generally as Umbrian or Roman school; the monument is to Cardinal Giovanni Sacco (d. 1505), attributed to the workshop of Bregno (Touring Club Italiano, *Roma e dintorni*, 1962, p. 457).

Prov. According to the Museum's records, bought by John Forster at the International Exhibition, London, 1873, for 75 guineas, but it does not appear in the *Official catalogue* of that exhibition; bequeathed to the Museum in 1876.

Jean Baptiste ROBIE (1821–1910)
Belgian School
Born and resident in Brussels, he painted mainly fruit and flower pieces.

188
FLOWERS AND FRUIT
Signed and dated lower left
J. Robie Bruxelles 1863
Canvas
52 × 38⅞ (132 × 98·7)
Dixon Bequest
1045–1886

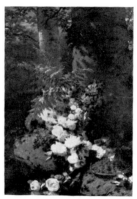

Prov. Joshua Dixon; bequeathed to Bethnal Green Museum in 1886.

189
FRUIT AND GAME
Signed and dated lower left
J. Robie Bruxelles 1864
Canvas
52 × 38⅞ (132 × 98·7)
Dixon Bequest
1044–1886

Prov. Joshua Dixon; bequeathed to Bethnal Green Museum in 1886.

José ROBLES Y MARTINEZ (b. 1843)
Spanish School
See Velazquez in vol. i of this catalogue.

8

August ROSENTHAL (b. 1820)
German School
A landscape and portrait painter, he was born in Hanover and worked mainly in Munich.

190
THE FOOT BRIDGE
Signed and dated lower right
A Rosenthal 1848 (A R in monogram)
Canvas
13½ × 19 (34·3 × 48·2)
Townshend Bequest
1575–1869

Prov. The Rev. C. H. Townshend; bequeathed to the Museum in 1868.

Carl ROTTMANN (1797–1850)
German (Munich) School
Born near Heidelberg, he was the pupil of his father, Friedrich Rottmann, and was early influenced by the work of the German romantic painter C. Ph. Fohr and by Claude and Poussin. From 1822 he lived in Munich, where he obtained the patronage of Ludwig I of Bavaria, to whom he subsequently became court painter. He travelled extensively in Italy in 1826–27, and 1829–30 and in Greece in 1834–35.

Rottmann is generally considered to have been the most important landscape painter in Munich in the first half of the 19th century. His influence may be seen in the work of Christian Morgenstern (Q.V.) and Eduard Schleich (Q.V.).

Lit. F. Kraus, *Carl Rottmann*, 1930; H. Decker, *Carl Rottmann*, Berlin, 1957.

191
THE BAY OF AULIS
Inscribed on back
Aulis/c. Rottmann gem[alt]/München 1848
Canvas
22 × 28¾ (56 × 78)
Townshend Bequest
1529–1869

At the request of Ludwig I of Bavaria, Rottmann painted twenty-three views of Greece in encaustic for the Neue Pinakothek in Munich. 1529–1869 is one of several reduced versions of the painting of Aulis in this series, which is dated 1847 (157 × 200 cm.; repr. Decker, *op. cit.*, fig. 230

& colour pl. 3). Decker (*op. cit.*, p. 82 f.) lists five other versions in oil (four in private collections, one in the Städelsches Kunstinstitut, Frankfurt) and two water-colours, as well as thirteen pencil sketches for the Munich version. The sketches probably date from the summer of 1835, when Rottmann was in Aulis.

Waagen praised 1529–1869 when he saw it in the Rev. C. H. Townshend's dining room in 1854–56: 'Few painters have rendered this classic scenery, so suggestive of thought to every instructed mind, with such poetic feeling as Rottmann . . .'

Prov. Bought by the Rev. C. H. Townshend before 1854–56, when it was seen in his collection by Waagen; bequeathed to the Museum in 1868.
Lit. Waagen, *Supplement*, 1857, p. 176.

Pierre Étienne Théodore ROUSSEAU (1812–67)
French School
Born in Paris in 1812, he was studying painting professionally with the painter Rédmond from the age of fourteen. He began painting from nature during excursions in the environs of Paris, including Fontainebleau, from 1826 to 1829. From 1831 to 1836 he exhibited at the Salon, but the naturalism of his landscapes made him the most controversial figure of his time and the consistent refusal of the Salon to accept any of his work between 1837 and 1848 earned him the title of *Le Grand Refusé*. From about 1837 he went to Barbizon nearly every year and became the central figure of the group of painters associated with that place, but public recognition came only with the Revolution of 1848 and the first class medal awarded by the free jury of the 1849 Salon.

Lit. R. L. Herbert, *Barbizon revisited*, New York, 1963.

192
A TREE IN FONTAINEBLEAU FOREST
On paper on canvas
$16\frac{1}{8} \times 21\frac{1}{2}$ (41·5 × 55)
Ionides Bequest
CAI.54

The back of the stretcher bears the inscription *Th. Rousseau vers 1840 Etude du Dormoir*. This date is acceptable on stylistic grounds, though the possibility of it being slightly later cannot be excluded, as Rousseau's treatment of landscape in long, broad and agitated brushstrokes continued into the late 1840s.

Condition. Cleaned in 1957.
Prov. Acquired by Constantine Alexander Ionides before 1884; bequeathed to the Museum in 1900.

Exh. French and Dutch Loan Collection, Edinburgh International Exhibition, 1886, no. 1146 (no. 96 of *Mem. cat.*).
Lit. Monkhouse, 1884, p. 42; A. Tomson, *Jean-François Millet and the Barbizon School,* 1903, facing p. 194; Sir C. Holmes in *Burl. Mag.,* vi, 1904, p. 26; Long, *Cat. Ionides Coll.,* 1925, p. 56; V. & A. Museum, *The Barbizon School,* 1965, p. 16, pl. 3.

193
LANDSCAPE WITH A STORMY SKY
Oil sketch on millboard
9¾ × 13⅞ (24·8 × 35·2)
Ionides Bequest
CAI.55

Datable c. 1842 on account of its close stylistic relationships with the 'Marais de la Souterraine' (John Tillotson collection; repr. Arts Council, *The Romantic Movement,* 1959, no. 310, pl. 28; Hazlitt Gallery, *Rousseau,* 1961, no. 23, Herbert, *Barbizon revisited,* no. 92, p. 184), which has been placed in 1842, the date of Rousseau's first visit to Berry.

Prov. Jules de Brawere, Expert, Brussels (seal on back); acquired by Constantine Alexander Ionides before 1884; bequeathed to the Museum in 1900.
Exh. French and Dutch Loan Collection, Edinburgh International Exhibition, 1886 no. 1169 (no. 97 of *Mem. cat.*).
Lit. Monkhouse, 1884, p. 42 f., repr.; *Memorial of the French and Dutch Loan Collection, Edinburgh International Exhibition 1886,* 1888 (repr. of a sketch of it by William Hole, R.S.A.); J. W. Mollett, *Millet, Rousseau, Diaz,* 1890, repr. facing p. 58; A. Tomson, *Jean-François Millet and the Barbizon School,* 1903, repr. facing p. 200; Sir C. Holmes in *Burl. Mag.,* vi, 1904, p. 26, repr. as frontispiece; Long, *Cat. Ionides Coll.,* 1925, p. 56, pl. 32; V. & A. Museum, *The Barbizon School,* 1965, p. 16, pl. 4.

194
A VIEW IN THE LANDES (NEAR BORDEAUX)
Signed and dated lower left
TH. Rousseau 1855
Panel
12⅜ × 20½ (31·4 × 52)
Townshend Bequest
1541–1869

This painting belongs to the period in the latter part of Rousseau's career, beginning in about 1852, when he came increasingly under the influence of the Dutch 17th century landscape painters, and his work betrays a greater emphasis on carefully finished execution.

Prov. The Rev. C. H. Townshend; bequeathed to the Museum in 1868.
Lit. V. & A. Museum, *The Barbizon School,* 1965, p. 16, pl. 6.

195
PONT DE BATIGNIES,
IN THE FOREST OF COMPIÈGNE
Signed lower right *TH. R*
On paper laid on canvas
Size of original painting $8\frac{3}{4} \times 12$
$(22 \cdot 2 \times 30 \cdot 5)$; present size
9×13 $(23 \times 33 \cdot 5)$
Ionides Bequest
CAI.56

The shadowy nature of the cow in the foreground and other weaknesses have led to doubt being cast upon this picture's authenticity. Recently, however, Hélène Toussaint of the Louvre (written communication) has convincingly identified it with an early work by Rousseau entitled *Pont de Batignies*, exhibited in 1867. The size given in the catalogue $(22 \times 31$ cm.) fits exactly and Mlle Toussaint was able to confirm her identification with reference to an engraving of the Pont de Batignies, now destroyed. The date given in the catalogue is 1828, when Rousseau was 14 or 15. (Cf. *Le Télégraphe de Montmartre*, at Boulogne, exh. *Rousseau*, Louvre, 1967-68, no. 1).

Prov. Constantine Alexander Ionides; bequeathed to the Museum in 1900.
Exh. Etudes peintes de Théodore Rousseau, Cercle des Arts, Paris, 1867, no. 6 (catalogue reprinted in P. Burty, *Maîtres et petits maîtres*, 1877, p. 77).
Lit. Long, *Cat. Ionides Coll.*, 1925, p. 57; V. & A. Museum, *The Barbizon School*, p. 16, pl. 5.

Hubert SALENTIN (1822–1910)
German (Düsseldorf) School
Born at Zülpich, he was a pupil of W. Schadow in Düsseldorf, where he settled. He painted mainly genre scenes.

196
THE RETURN FROM THE CHRISTENING
Signed and dated lower right
Hubert Salentin Ddrf [Düsseldorf]
1859
Canvas
$22\frac{3}{4} \times 27\frac{3}{4}$ $(57 \cdot 8 \times 70 \cdot 5)$
515–1870

Prov. John Parsons; bequeathed to the Museum in 1870.

Edmond de SCHAMPHELEER (1824–99)
Belgian School
Born in Brussels, he studied at Antwerp and Munich, and then settled in
Brussels. He was a landscape painter.

197
DORDRECHT, WITH SHIPPING ON THE
MEUSE
Signed and dated lower left
E. de Schampheleer 1873
Canvas
37⅞ × 57⅜ (96·2 × 145·7)
Dixon Bequest
1056–1886

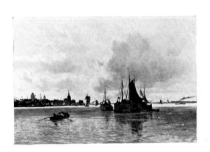

Prov. Joshua Dixon; bequeathed to Bethnal Green Museum in 1886.
Lit. Shaw Sparrow, 1892, p. 160 f., repr.

Ary SCHEFFER (1795–1858)
Dutch School; worked in Paris
Born at Dordrecht, he lived in The Hague (1797–1808) and Amsterdam
(1808–10). In 1812 he went to Paris and was, with Géricault and Delacroix,
a pupil of P. N. Guérin. He exhibited regularly at the Paris Salon and
became a very popular painter of portraits and figure subjects. From 1830
his work became increasingly hallmarked by the soulful expressions of the
figures. There is a museum dedicated to him in Dordrecht.

198
CHRIST WEEPING OVER JERUSALEM
Signed, and dated lower left
Ary Scheffer 1849
Canvas
33¼ × 26 (84·5 × 66)
142–1878

An identical version was in the Baroda collection (photograph in Witt
Library, Courtauld Institute).

Prov. Perhaps identical with lot 87 at the L. Pocock Sale, Christie's, 17 May 1873,
bought in for £997 10s; Mrs Murray Miller; given to the Museum in 1878.

Andreas SCHELFHOUT (1787–1870)
Dutch School
He was born at The Hague, where he became a pupil of J. H. Breckenheimer
and where he lived most of his life. The teacher of J. B. Jongkind, he was
well known as a landscape painter and lithographer in his time.

199
LANDSCAPE NEAR HAARLEM
Signed and dated lower left
A. Schelfhout f39
Oak panel
$11\frac{1}{2} \times 16\frac{1}{4}$ (41·5 × 29)
Townshend Bequest
1576–1869

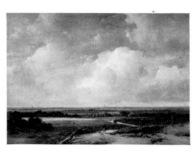

Prov. The Rev. C. H. Townshend; bequeathed to the Museum in 1868.

200
SKATING IN HOLLAND
Signed lower left *A Schelfhout f 46*
Oak panel
$18\frac{3}{4} \times 25$ (47·6 × 63·5)
Townshend Bequest
1530–1869

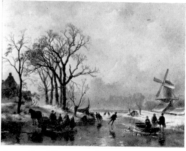

Prov. The Rev. C. H. Townshend; bequeathed to the Museum in 1868.

Eduard SCHLEICH (1812–74)
German (Munich) School
Having studied at the Munich Academy, he went to Rome with Karl
Spitzweg in 1851. Subsequently he settled in Munich and became one of
the leading landscape painters of the Munich school.

201
PLOUGHING IN BAVARIA
Signed lower right *Ed. Schleich*
Canvas
12 × 26 (30·5 × 66)
Townshend Bequest
1536–1869

Prov. The Rev. C. H. Townshend; bequeathed to the Museum in 1868.

202
DEER AT DAWN NEAR MUNICH
Signed lower left *Ed. Schleich*
Canvas
12 × 24½ (30·5 × 62·2)
Townshend Bequest
1537–1869

Waagen considered that 'this picture shows great feeling for nature and truth of effect . . .'

Condition. Paint surface cracked in sky.
Prov. Acquired by the Rev. C. H. Townshend before 1854–56, when it was seen by Waagen in his dining room; bequeathed to the Museum in 1868.
Lit. Waagen, *Supplement*, 1857, p. 178.

203
LANDSCAPE WITH FIGURES, AND
CATTLE GRAZING
Signed lower right *Ed. Schleich*
Panel
13⅞ × 19¼ (35·2 × 49)
Townshend Bequest
1559–1869

Prov. The Rev. C. H. Townshend; bequeathed to the Museum in 1868.

204
LANDSCAPE WITH CATTLE AT A STREAM
Signed lower right *Ed. Schleich*
Canvas
15⅛ × 28¼ (38·4 × 71·8)
Townshend Bequest
1566–1869

Prov. The Rev. C. H. Townshend; bequeathed to the Museum in 1868.

205
CARRYING CORN
Signed lower left *Ed. Schleich*
Canvas
17 × 21 (43·2 × 53·3)
Townshend Bequest
1569–1869

Prov. The Rev. C. H. Townshend; bequeathed to the Museum in 1868.

Carl SCHLESINGER (1825–93)
Swiss/German School
Born in Lausanne, he studied in Hamburg, Prague and in Antwerp under
L. Dyckmans. From 1852 he lived in Düsseldorf.

206
THE HAY WAGON
Signed lower right *C. Schlesinger*
Canvas
13½ × 19¾ (34 × 50)
514–1870

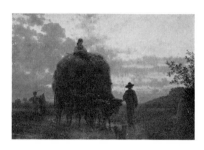

Prov. John Parsons; bequeathed to the Museum in 1870.

V. SCHOUTEN (active mid-19th century)
Dutch School

207
THE REHEARSAL: AN 18TH CENTURY
COSTUME PIECE
Signed lower left *V. Schouten*
Oil on rep
25½ × 49 (64·7 × 124·5)
Dixon Bequest
1066–1886

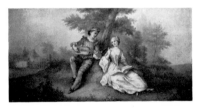

The use of rep – a textile characterized by its corded surface – suggests
that this picture was intended to have the appearance of a tapestry. It is a
typical example of the 'second rococo' of the mid-19th century.

Prov. Joshua Dixon; bequeathed to Bethnal Green Museum in 1886.

Julius Friedrich Antonio SCHRADER (1815–1900)
German (Berlin) School
Born in Berlin, he studied at the Academy there from 1820 and at the
Düsseldorf Academy under W. Schadow in 1837–44. Subsequently he
travelled in Belgium, France, Italy and England and settled in Berlin in
1848.

208
ITALIAN WOMEN IN A VINEYARD NEAR
ROME
Signed and dated lower right
J. Schrader 1848
Canvas
44 × 55¾ (111·7 × 141·6)
630–1901

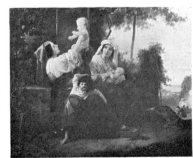

In the R. A. catalogue, 1849, no. 540, the subject is described as: 'Two Italian women, seated with their children in a vineyard at the foot of the Albanian mountains, Ostea.' This would seem to set the scene in the Colli Albani south of Rome, but Ostia is some 15 miles away.

Prov. Sir Edwin Durning-Lawrence, Bt; given to the Museum in 1901.
Exh. R. A. 1849, no. 540.

Georg SCHWER (1827–77)
German (Düsseldorf) School
Born at Nuremberg, Schwer studied in London and subsequently settled in Düsseldorf. He painted landscapes and figure subjects.

209
GIRL GATHERING STICKS
Signed and dated lower left
G. Schwer Düsseldorf 1860
Canvas
40½ × 31¾ (103 × 80·6)
Townshend Bequest
1580–1869

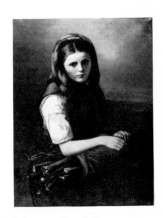

Prov. The Rev. C. H. Townshend; bequeathed to the Museum in 1868.

210
TRAVELLING DOG CART
Signed and dated lower right
G Schwer Düss, 60
Canvas
20¾ × 27 (52·7 × 68·6)
Townshend Bequest
1610–1869

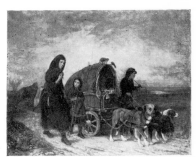

The cart belongs to travelling performers. It contains a monkey and a tambourine; on top is a monkey with a soldier's hat, and a parrot.

Prov. The Rev. C. H. Townshend; bequeathed to the Museum in 1868.

Carl Wilhelm Anton SEILER (1846–1921)
German School
Born at Wiesbaden, he studied art at Berlin and Munich. He lived in Berlin, where he taught at the Academy in 1894–95, and in Munich.

211
LITERARY RESEARCHES: AN 18TH
CENTURY COSTUME PIECE
Signed and dated lower left
C. Seiler 1881
Panel
$9\frac{1}{2} \times 7\frac{5}{8}$ (24 × 19·4)
Dixon Bequest
1041–1886

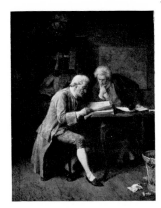

Prov. Joshua Dixon; bequeathed to Bethnal Green Museum in 1886.
Lit. Shaw Sparrow, 1892, p. 164, repr.

212
CONVERSATION PIECE: THREE MEN IN
18TH CENTURY COSTUME
Signed and dated lower right
C. Seiler, *1890*
Panel
10 × 12 (25·2 × 30·3)
P.48–1917
Not reproduced

Prov. Thomas M'Lean, art dealer, Haymarket (label at back); Henry L. Florence;
bequeathed to the Museum in 1917.

213
COUNT BRUEHL'S GOAT
Signed and dated lower left
C. Seiler, *1892*
Panel
13 × $9\frac{3}{4}$ (33 × 24·8)
P.24–1917

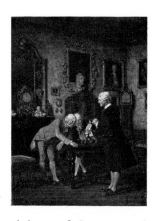

Heinrich, Count Brühl (1700–63), was prime minister of Saxony and
director of the Meissen porcelain factory. The porcelain group of a man
riding a goat represents the Meissen group popularly known as 'Count
Brühl's Tailor'. It was modelled by Kändler in 1740 and seems to have
had no particular connection with either Count Brühl or his tailor; the
factory record merely refers to a tailor riding on a goat (Y. Hackenbroch,

Meissen and other Continental porcelain, faience and enamel in the Irwin Untermyer Collection, Cambridge, Mass., 1956, p. 119). The companion piece of the tailor's wife was also modelled in 1740. The interpretation of the figure as a satire of Count Brühl's tailor, who had asked to be present at a banquet, is of later origin (W. B. Honey, *Dresden china,* 1946, p. 111). There is an example of the group in the Museum (c.982–1919).

Prov. Henry L. Florence; bequeathed to the Museum in 1917.

Johann Gottfried STEFFAN (1815–1905)
Swiss/German School
Born in Wädenswill (Canton Zürich) he studied lithography at the Munich Academy from 1833 and subsequently took up painting. He was influenced by the Dutch landscape painters and by Rottmann.

214
THE TORRENT
Signed lower right
J. G. Steffan p. *1844 München*
Canvas
$31\frac{3}{4} \times 46\frac{1}{2}$ (80·6 × 118)
Townshend Bequest
1545–1869

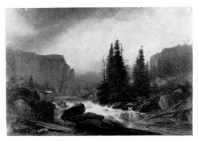

Prov. The Rev. C. H. Townshend; bequeathed to the Museum in 1868.

Franz STEINFELD (1787–1868)
Austrian (Vienna) School
Born in Vienna, where he studied at the Academy in 1802, he travelled widely in Europe, particularly in the Netherlands, and he was strongly influenced by the Dutch landscape painters of the 17th century. In 1823 he became a member of the Vienna Academy, and subsequently a professor there, as well as official painter to Archduke Anton of Austria.

215
LANDSCAPE: THE RIVER BANK
Panel
$7\frac{1}{2} \times 9\frac{1}{4}$ (19 × 23·5)
Townshend Bequest
1534–1869

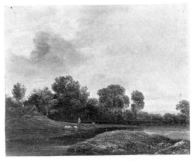

Prov. The Rev. C. H. Townshend; bequeathed to the Museum in 1868.

Marius STEINLEN (1826–66)
Swiss School
Born at Vevey, where he later taught at the School of Art, he studied in
Geneva and Paris. He was the uncle of Théophile Steinlen.

216
DRAWING WATER
Signed and dated lower left
M. Steinlen 1855
Canvas
$9\frac{5}{8} \times 7\frac{1}{2}$ (24·4 × 19)
Townshend Bequest
1628–1869

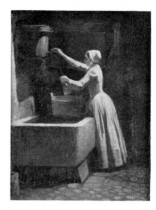

Prov. The Rev. C. H. Townshend; bequeathed to the Museum in 1868.

SWISS School, mid-19th century

217
THE EXECUTION OF MAJOR DAVEL
Panel
$10\frac{3}{4} \times 8\frac{1}{2}$ (27·3 × 21·5)
Townshend Bequest
1617–1869

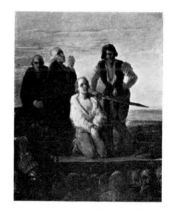

Jean Daniel Abraham Davel (1670–1723) was a Vaudois patriot. From
1689 he saw service in Swiss regiments in Piedmont, Holland and France,
but his claim to fame rests on his attempt, in 1723, to rally the people of
Lausanne in the cause of Vaudois independence against the domination of
Bern. He failed to persuade the inhabitants to revolt and was rapidly
arrested, condemned and executed.

The composition of 1617–1869 has some similarities with Charles
Gleyre's well-known depiction of this scene (c. 1850, Lausanne Museum;
C. Clément, *Gleyre*, 2nd ed., 1886, p. 407, no. 57), but there are too many
differences to warrant the assumption of a direct connection.

Prov. The Rev. C. H. Townshend; bequeathed to the Museum in 1868.

Nicolas Antoine TAUNAY (1755–1830)
French School
Born in Paris, the son of the painter Pierre Antoine Henry Taunay, he
was for a short time a pupil of Lépicié. In 1784 he became agréé of the
Académie royale and from then until 1787 he was in Rome on an official
stipend. He went to Rio de Janeiro in 1816 to advise on the reorganization
of the Academy of Fine Arts and remained there until 1822. He settled in
Paris and two years later became a Chevalier of the Legion of Honour.

218
COAST SCENE, RIO DE JANEIRO
Signed on the sail of a boat on left
Taunay
Canvas
18 × 22¼ (45·7 × 56·5)
Townshend Bequest
1612–1869

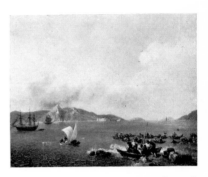

Taunay was in Rio from 1816 to 1822; according to A. d'E. Taunay (1911)
this painting dates from 1817.

Prov. The Rev. C. H. Townshend; bequeathed to the Museum in 1868.
Lit. A. d'E. Taunay, 'A missão artistica 1816' in *Revista do Instituto Historico e
Geographico Brazileiro*, 74, pt 1, 1911, repr. p. 112 (deals with Taunay pp. 26–
149); Thieme-Becker, xxxii, 1938, p. 474.

Friedrich THURAU (active 1837; d. 1888)
German School
A landscape painter, he was born in Stargard, Pomerania and lived in
Constance from 1837 until his death in 1888.

219
LAKE SCENE WITH HERONS
Canvas
25 × 32½ (63·5 × 82·5)
Townshend Bequest
1552–1869

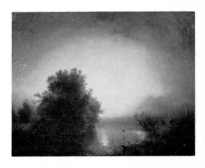

Prov. The Rev. C. H. Townshend; bequeathed to the Museum in 1868.

Benjamin VAUTIER (1829–98)
Swiss (Geneva) School; worked in Germany
Born at Morges on Lake Geneva, he was a pupil of Jules Hébert in
Geneva in 1847, and at the Düsseldorf Academy in 1850–53. He settled in
Düsseldorf in 1857 and subsequently became a successful painter of
peasant genre scenes.

Lit. F. Pecht, 'Zu Benjamin Vautiers 60. Geburtstage' in *Die Kunst für Alle*, iv,
April 1889, p. 209 ff.

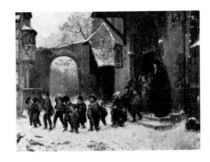

220
SNOW SCENE: CHILDREN LEAVING
SCHOOL
Signed on stone lower right
B. VAUTIER
Canvas
18¾ × 14¼ (47·6 × 36·2)
Townshend Bequest
1604–1869

Probably to be identified with a composition by Vautier entitled *Sortie
d'école et boules de neige* listed under the year 1853 in C. Brun, *Schwei-
zerisches Künstlerlexikon*, iii, 1913, p. 366.

Prov. The Rev. C. H. Townshend; bequeathed to the Museum in 1868.

Eugène Joseph VERBOECKHOVEN (1799–1881)
Belgian School
Born in Warneton, West Flanders, he settled as a painter in Ghent in 1820.
He made several journeys to France, Germany and Italy and visited
England in 1824 and 1826. A prolific painter, he specialized in animal
scenes, with a particular fondness for cows, horses, donkeys and sheep.

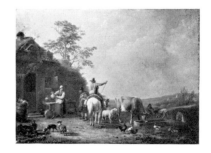

221
WATERING CATTLE
Signed lower centre
Eugène Verboeckhoven ft. 1845
Panel
17¼ × 23¼ (43·8 × 59)
Townshend Bequest
1528–1869

Prov. The Rev. C. H. Townshend; bequeathed to the Museum in 1868.

222
LANDSCAPE WITH DONKEY
Signed and dated on left
Eugène Verboeckhoven f. 1846
Panel
5 × 6¾ (12·7 × 17)
Dixon Bequest
1085–1886

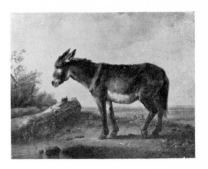

Prov. Joshua Dixon; bequeathed to Bethnal Green Museum in 1886.
Lit. Shaw Sparrow, 1892, p. 163 f., repr.

223
DONKEY AND LAMBS
Signed lower left
E. J. Verboeckhoven 1849
Canvas
8⅝ × 7¾ (22 × 19·7)
Townshend Bequest
1532–1869

According to Waagen: 'The truth of the animals, and the admirable aerial perspective, place this little picture among the best by this unequal master.'

Condition. Cleaned in 1958–59.
Prov. Bought by the Rev. C. H. Townshend soon after it was painted (seen by Waagen in Townshend's dining room in 1854 or 1856) and bequeathed by him to the Museum in 1868.
Lit. Waagen, *Supplement*, 1857, p. 176.

224
LANDSCAPE WITH SHEEP AND DUCKS
Signed and dated lower centre
Eugène Verboeckhoven 1865
Oak panel
6¾ × 9 (17 × 22·8)
493–1870

Prov. John Parsons; bequeathed to the Museum in 1870.

Theodor VERHAS (1811–72)
German School
Born at Schwetzingen, he studied in Karlsruhe and at the Munich
Academy. He lived in Munich in the 1840s and, from 1856, in Heidelberg.
His work shows the influence of 17th century Dutch landscape painting.

225
SNOW SCENE WITH BUILDINGS AND
TOWER
Signed lower right *T V* (monogram)
Mahogany panel
16¾ × 13¾ (42·5 × 34·9)
Townshend Bequest
1549–1869

Prov. The Rev. C. H. Townshend; bequeathed to the Museum in 1868.

Wouter VERSCHUUR (1812–74)
Dutch School
Born in Amsterdam, he painted mainly scenes with horses in the manner of
Wouverman.

226
INTERIOR OF A STABLE
Signed and dated lower left
W. Verschuur 53 (?)
Panel
14¾ × 20⅝ (36·5 × 52·4)
Dixon Bequest
1060–1886

Prov. Joshua Dixon; bequeathed to Bethnal Green Museum in 1886.

(Johann) Georg VOLMAR (1770–1831)
German School; worked in Switzerland
Born in Mengen (Württemberg), a member of a family of painters, he
came early to Zurich, where he worked for Lavater. In 1789 he was in
Lausanne working as a miniaturist and a year later he moved to Bern,

where he became a professor at the School of Art. He painted mainly
history and costume pieces and battle scenes.

227
BRIGANDS SURPRISED
Signed lower right *G. Volmar*
Panel
13⅝ × 11 (34·6 × 28)
Townshend Bequest
1547-1869

A piece of wood in the foreground – part of an opened crate – is inscribed
No. 37. B:K:
Condition. Marked craquelure on paint surface.
Prov. The Rev. C. H. Townshend; bequeathed to the Museum in 1868.

228
THE CAPTIVE
Signed lower right *G. Volmar*
Panel
13⅝ × 11 (34·5 × 28)
Townshend Bequest
1548-1869

To judge from the costume, the date is c. 1810.
Condition. Marked craquelure on paint surface.
Prov. The Rev. C. H. Townshend; bequeathed to the Museum in 1868.

Johannes WEILAND (1865-1909)
Dutch School
Primarily a genre painter, he was a pupil of the Rotterdam Academy, where
he later taught.

229
INTERIOR WITH AN OLD LADY SEATED
AND CUTTING CLOTH
Signed and dated lower right
J. Weiland 98 (the J and W form a
monogram)
Canvas
$21\frac{1}{2} \times 25\frac{5}{8}$ (54·5 × 65)
P.69–1917

Prov. Thomas M'Lean, art dealer, Haymarket (label on stretcher); Henry L. Florence; bequeathed to the Museum in 1917.

Albert ZIMMERMANN (1808–88)
German School
Born at Zittau, he studied at the Academies in Dresden and Munich. In 1857 he was appointed by the Austrian government to a professorship at the Milan Academy and from 1860 to 1871 he taught at the Academy in Vienna. He painted mainly landscapes in a naturalistic style.

230
HAYMAKING
Signed and dated lower left
A. Zīmermañ München 1838
Panel
22 × 18 (55·8 × 45·7)
1533–1869

Presumably painted during the artist's period as a student at the Munich Academy.
Prov. The Rev. C. H. Townshend; bequeathed to the Museum in 1868

231
LAKE OF CONSTANCE
Ash panel
$22\frac{1}{4} \times 29\frac{1}{4}$ (56·5 × 74·3)
Townshend Bequest
1567–1869
Not reproduced

Condition Paint surface has been subject to blistering.
Prov. The Rev. C. H. Townshend; bequeathed to the Museum in 1868.

Friedrich ZIMMERMANN (1823–84)
Swiss (Geneva) School
Born at Diessenhofen (Thurgau), he was a pupil of Calame in 1852 and lived mostly in Geneva.

232
LAKE OF THE ENGSTLEN ALP
Signed lower right *Frdr. Zimmermann*
Canvas
23 × 31¾ (58·4 × 80·7)
Townshend Bequest
1581–1869

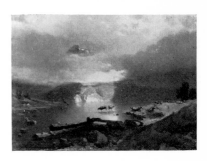

Prov. The Rev. C. H. Townshend; bequeathed to the Museum in 1868.

Reinhard Sebastian ZIMMERMANN (1815–93)
German (Munich) School
Born at Hagnau on Lake Constance, he became a pupil of Schnorr von Carolsfeld and Heinrich Hess at the Munich Academy in 1840. After extensive travels in Europe (1845–46) and a brief residence in Constance (1846–47) he settled in Munich. He became court painter to the Dukes of Baden-Württemberg and specialized in Swabian and Bavarian genre scenes.

233
MONASTIC LIBRARY
Signed lower left *R. S. Zimmermann*
Panel
12⅝ × 20⅛ (32 × 51)
Dixon Bequest
1064–1886

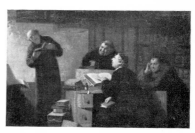

Prov. Joshua Dixon; bequeathed to Bethnal Green Museum in 1886.

Luigi ZUCCOLI (1815–76)
Italian School
Born in Milan, where he studied and lived, he was in England in 1864–65 and 1871, when he exhibited at the R. A. After visits to Belgium and Rome (c. 1868–70) he returned to Milan and became a member of the Academy there. He painted portraits and genre scenes, and some religious subjects.

234
CHARITY: INTERIOR WITH FIGURES
Signed lower right *Luigi Zuccoli*
Canvas
$38\frac{1}{2} \times 31\frac{1}{4}$ (97·8 × 79·4)
Dixon Bequest
1057–1886

Prov. Joshua Dixon; bequeathed to Bethnal Green Museum in 1886.
Exh. R. A. 1864, no. 479.

Anton ZWENGAUER (1810–88)
German (Munich) School
Born in Munich, where he was a pupil of Peter Cornelius and where he
became curator of the Schleissheim Galerie and then of the Pinakothek, he
was popular for his depiction of local views at sunset.

235
LAKE OF CONSTANCE, SUNSET
Signed and dated lower left
A Zwengauer (AZ monogram) *1848*
Canvas
$21\frac{1}{4} \times 31\frac{1}{2}$ (54·6 × 80)
Townshend Bequest
1543–1869

Waagen wrote of this picture: 'The peaceful feeling of a fine summer's
evening is most happily expressed; the effect is clear and true, and the
execution conscientious.'

Prov. Acquired by the Rev. C. H. Townshend before 1854–56, when it was seen
by Waagen in his dining room; bequeathed to the Museum in 1868.
Lit. Waagen, *Supplement*, 1857, p. 177.

List of Artists by Schools

Austrian

Blaas	Koller	Steinfeld
Gauermann	Kuwasseg	

Belgian

Baugniet	Delfosse	Lamorinière	Robie
Bossuet	Dillens	Leys	Schampheleer
Braekeleer	Dyckmans	Luppen	Verboeckhoven
Carabain	Jacobs	Ommeganck	
Clays	Keyser	Pulinckx	

Danish

Libert

Dutch

Groot	Koekkoek, H.	Moll	Verschuur
Haanen	Koster	Scheffer	Weiland
Hove	Lamme	Schelfhout	
Klombeck	Maris, M.	Schouten	

French

Bavoux	Corot	Fantin-Latour	Michel
Bellenger	Courbet	Ingres	Millet
Blanc	De Dreux	Jadin	Montagny
Bonheur	Degas	Lafaye	Montpezat
Bonnet	Delacroix	Lambinet	Philippoteaux
Brascassat	Delaroche	Le Poittevin	Puvis de Chavannes
Browne	Diaz	L'Hermitte	Regamey
Chevilliard	Dupré, L. V.	Loyeux	Rousseau
Cornilliet	Duverger	Margry	Taunay

German

Baisch	Hildebrandt	Lindlar	Seiler
Dolmus	Hoguet	Piltz	Thurau
Halle	Kirner	Rosenthal	Verhas
Heffner	Kuehl	Schrader	Volmar
			Zimmermann, A.

(Düsseldorf)

Adloff	Lasch	Salentin
Bochmann	Oehmichen	Schlesinger
Deiters	Preyer	Schwer

(Munich)

Bauer	Koeckert	Rottmann	Zwengauer
Dürck	Malchus	Schleich	
Ezdorf	Morgenstern	Zimmermann, R. S.	

Italian

Bonifazi	Castelli	Giovanni	Zuccoli
Caracciolo	Gamba	Rizzoni	

Norwegian

Baade
Munthe

Spanish

Aranda	Galofre
Benlliure	

Swedish

Hermelin

Swiss

Bocion	George	Lugardon, A.	Rischgitz
Bryner	Hornung	Lugardon, J. L.	Steffan
Calame	Humbert	Menn	Steinlen, M.
Diday	Kunkler	Mennet	Vautier
Frey	Lacaze	Muyden	Zimmermann, F.

Subject Index

References are to catalogue numbers

Numerical Index

Museum number	Catalogue number	Museum number	Catalogue number
1034–1869	14	1561–1869	105
1035–1869	50	1562–1869	144
1381–1869	85	1563–1869	18
1528–1869	221	1564–1869	9
1529–1869	191	1565–1869	123
1530–1869	200	1566–1869	204
1532–1869	223	1567–1869	231
1533–1869	230	1568–1869	120
1534–1869	215	1569–1869	205
1535–1869	64	1570–1869	136
1536–1869	201	1571–1869	141
1537–1869	202	1572–1869	106
1538–1869	71	1573–1869	142
1539–1869	103	1574–1869	107
1540–1869	110	1575–1869	190
1541–1869	194	1576–1869	199
1542–1869	135	1577–1869	140
1543–1869	235	1578–1869	49
1544–1869	148	1579–1869	6
1545–1869	214	1580–1869	209
1546–1869	169	1581–1869	232
1547–1869	227	1582–1869	68
1548–1869	228	1583–1869	186
1549–1869	225	1584–1869	22
1550–1869	119	1585–1869	25
1551–1869	104	1586–1869	26
1552–1869	219	1587–1869	19
1553–1869	143	1588–1869	27
1554–1869	43	1589–1869	28
1555–1869	5	1590–1869	29
1556–1869	77	1591–1869	24
1557–1869	118	1592–1869	16
1558–1869	122	1593–1869	30
1559–1869	203	1594–1869	20
1560–1869	137	1595–1869	21

Museum number	Catalogue number	Museum number	Catalogue number
1596–1869	109	570–1870	174
1597–1869	35	1–1871	76
1598–1869	154	1324–1871	63
1599–1869	155	376–1876	125
1600–1869	156	377–1876	126
1601–1869	157	142–1878	198
1602–1869	158	84–1880	176
1603–1869	92	85–1880	175
1604–1869	220	86–1880	117
1605–1869	111	579–1882	180
1606–1869	149	298–1886	39
1607–1869	44	1041–1886	211
1608–1869	8	1044–1886	189
1609–1869	128	1045–1886	188
1610–1869	210	1046–1886	96
1611–1869	159	1047–1886	151
1612–1869	218	1048–1886	124
1613–1869	32	1050–1886	69
1614–1869	108	1051–1886	147
1615–1869	130	1052–1886	173
1616–1869	72	1053–1886	150
1617–1869	217	1056–1886	197
1618–1869	172	1057–1886	234
1619–1869	160	1058–1886	87
1620–1869	10	1059–1886	167
1621–1869	23	1060–1886	226
1622–1869	17	1061–1886	15
1623–1869	31	1062–1886	33
1626–1869	41	1063–1886	170
1627–1869	42	1064–1886	233
1628–1869	216	1065–1886	4
1631–1869	115	1066–1886	207
1632–1869	116	1067–1886	121
1633–1869	145	1069–1886	36
493–1870	224	1070–1886	47
500–1870	146	1071–1886	37
502–1870	94	1072–1886	133
514–1870	206	1073–1886	34
515–1870	196	1074–1886	75
517–1870	1	1075–1886	181
518–1870	2	1076–1886	13
523–1870	3	1077–1886	48
527–1870	59	1079–1886	93
560–1870	73	1080–1886	171
561–1870	74	1081–1886	7

Museum number	Catalogue number	Museum number	Catalogue number
1082–1886	70	CAI.48	163
1083–1886	40	CAI.49	164
1084–1886	134	CAI.54	192
1085–1886	222	CAI.55	193
1292–1886	46	CAI.56	195
863–1894	98	CAI.57	112
864–1894	97	CAI.58	113
865–1894	99	CAI.59	54
866–1894	101	CAI.60	55
867–1894	100	CAI.61	65
431–1895	129	CAI.62	66
321–1899	114	CAI.63	60
1846–1900	89	CAI.64	61
628–1901	45	CAI.65	51
630–1901	208	CAI.66	52
744–1902	56	CAI.67	161
745–1902	57	CAI.68	138
553–1903	62	CAI.69	139
1581–1904	178	CAI.71	183
59–1908	102	CAI.72	184
60–1908	152	CAI.73	185
E.917–1911	182	CAI.88	38
P.23–1917	12	CAI.90	153
P.24–1917	213	CAI.128	78
P.25–1917	53	CAI.129	79
P.26–1917	95	CAI.130	80
P.47–1917	81	CAI.164	67
P.48–1917	212	CAI.172	165
P.52–1917	127	CAI.1151	11
P.53–1917	88	F.17	132
P.69–1917	229	F.33	187
P.70–1917	179	F.A.77	90
P.47–1919	166	F.A.78	91
P.1–1935	177	S.Ex.61–1882	82
P.44–1962	86	S.Ex.24–1884	83
P.9–1966	131	S.Ex.191–1886	168
CAI.19	58	S.Ex.4–1889	84
CAI.47	162		